Angels of Paris

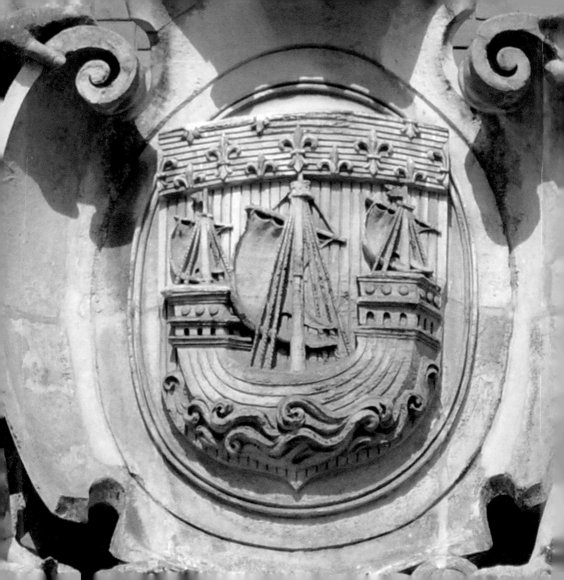

ANGELS
OF · PARIS

ROSEMARY FLANNERY

An Architectural Tour through the History of

Paris

with PHOTOGRAPHS by the author

THE LITTLE BOOKROOM ◆ NEW YORK

© 2012 The Little Bookroom
Text © 2012 Rosemary Flannery
Photographs © 2012 Rosemary Flannery
Cover design: Claudia De Almeida

Image credits
Page 46: Tombstone of Nicolas Flamel, by kind permission of the Réunion des Musées Nationaux.
Page 62: Drawing of lighthouse from the Revue Générale de l'Architecture, 1852,
possibly Emil-August Delange, by kind permission of the Bibliothèque Historique de la Ville de Paris.
Page 94: Angel coin, circa 1471-83, by kind permission of Jeff Kahn of Gold-stater.com.

Library of Congress Cataloging-in-Publication Data

Flannery, Rosemary.
The angels of Paris / by Rosemary Flannery ;
photographer/illustrator, Rosemary Flannery.
p. cm.
Includes bibliographical references and index.
ISBN 978-1-936941-01-8 (alk. paper)
1. Angels in art--Pictorial works. 2. Decoration and ornament, Architectural--France--Paris--Pictorial works. 3. Figure sculpture--France--Paris--Pictorial works. 4. Historic buildings--France--Paris--Pictorial works. 5. Monuments--France--Paris--Pictorial works. 6. Paris (France)--Buildings, structures, etc.--Pictorial works. 7. Figure sculpture--France--Paris--History.
8. Sculpture, French--France--Paris--History. 9. Paris (France)--Description and travel. I. Title.
NA3549.P2F536 2012
704.9'46640944361--dc23
2012017599

Printed in The United States of America

Published by The Little Bookroom
435 Hudson Street, Suite 300
New York NY 10014
editorial@littlebookroom.com
www.littlebookroom.com

ISBN 978-1-936941-01-8

2 4 6 9 0 9 7 5 3 1

Contents

Introduction

*A*ngels of Paris was born of my feeling that Paris is a protected city. Paris has been spared throughout the ages: passed over by the Huns in the 5th century, saved from Frankish tribes in the 6th, and, unlike other European cities, left unscathed by World War II.

Walking through the capital, I noticed angels in the most unexpected places, and they seemed, curiously, to echo my fanciful idea that enchanting Paris is an enchanted city. I found these beautiful spirits in every arrondissement, dating from every period. Parisian architects and artists depicted angels of all shapes and sizes, ages and genders, from the Middle Ages through the 20th century.

Some turned up as trusty defenders, like the duo of cherubs holding a lightning rod above a theatre, or the brave archangel crushing a reptilian demon over a lofty bell tower. Other angels emerged flying in to work on railroad tracks, or posted above the entrance to an apartment building, welcoming visitors and passersby. Still more embellish sundials, clocks, or fountains. Many angels, of course, watch over churches and chapels, praying or playing instruments, grieving, rejoicing, burning incense, or delivering messages. Some advertise cookies on bakeries; still others greet opera-goers, or tame lions outside museums.

Angels are considered to be celestial beings, forging a link between heaven and earth. The word "angel" derives from the Greek *angelos*, or messenger, and they are often described as such in the writings of Christianity, Judaism, and Islam; in the religion of ancient Iran, Zoroastrianism, angels are guardians and act as "beneficent immortals." While the Christian archangels Michael, Gabriel, and Raphael are all masculine, many others are androgynous. From the time of Constantine in the 4th century, angels were depicted winged, and often haloed; in *Angels of Paris* all the angels are winged and some have haloes. Many believe these attributes derive from the aspect of ancient Greek divinities.

In French civic architecture, angels take on different names: *renommées* if celebrating the renown of a person or a group; *angelots* for baby angels, a version of the Italian *putti* or little boy cherubs; and *génies* or *amours* if found on buildings other than churches.

Most fascinating of all, the angels of Paris reflect *l'esprit du temps*, the spirit of their times. Some blow trumpets to celebrate a king's victories, or carry a laurel wreath to honor the emperor; others mourn victims of the Commune or were once hacked off churches during the Revolution. They all tell the story of the city during peace, revolution, turmoil, and triumph.

Their creators—artistic alchemists who transformed stone, mosaic, bronze, marble, or ceramic into fantastic spirits in an exquisite contradiction—drew me into their universe. The anonymous masters of the Middle Ages adorned churches, abbey townhouses, and even private homes with angels, some poignant, others whimsical. Sculptors of the Royal Academy studied the masters in Italy and returned to Paris with new inspiration. Angels appeared on mansions, monuments, and churches, lushly sculpted, often bearing allegories or a coat-of-arms.

During the reconstruction of Paris in the 19th century, artists employed by the city or by private contractors created sundry angels to soften the strict lines of the new Haussmannian buildings, enlivening façades or tucked under balconies. As styles evolved, so did the angels. Art Nouveau angels curved to the "noodle art"; the Belle Epoque was rich with angels of rhythmic design. Art Deco angels were set into block-like shapes; their successors took on a streamlined, modern look.

Angels of Paris is a hymn to all of the angels, both real and in art, and to the sculptors and the architects that made Paris the beautiful city that it is today. This book is my love song to Paris, a song of gratitude and appreciation to my adopted city. My mission has been to share the beautiful things I've seen and the interesting things I've learned along the way, and to give praise to those who made it happen. I hope you will enjoy it.

Rosemary Flannery
Paris 2012

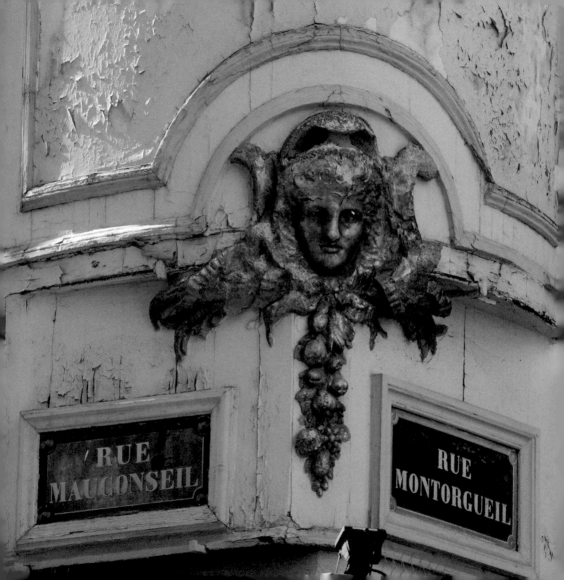

The Mascaron Angel
(circa 1723-1760)

✦

A haloed and gilded wooden angel's head dazzles from above adjacent street signs in Les Halles. Wreathed in wings scrolled back, and with a decorative braid of fruit tumbling down the building's edge, the sculpture of a stylized face smiles enigmatically. When it was put there, by whom, and why, remains a mystery; this may not even have been her original setting, as ornaments often were moved from one house to be placed on another as old buildings were demolished and streets renovated.

There is something poetic about the angel's head, which has the aura of a dramatic mask. *Mascarons*—little masks, or stylized faces—were a particular decorative element of Louis XV-style architecture, circa 1723-1760, when this area was known as an important theatrical district. The rue Mauconseil had been the haunt and home of actors dating from the time of the Théâtre de l'Hôtel de Bourgogne, which was built during the Renaissance by a troupe of actors called the Confrères de la Passion. They would later rent the theatre out to the Troupe Royale des Comédians before being merged with the Palais-Royal performers in 1680. Italian actors of the Comédie-Italienne would then take the stage, until being ousted in 1697 by Louis XIV because their play, *La Fausse Prude*, ridiculed Madame de Maintenon, the king's second wife. Various troupes succeeded them until the theatre's demolition in 1783.

Today, the corner is part of a lively neighborhood full of food purveyors, cafés, and restaurants. The angel's head shines above, an unexpected sparkle amidst the bustle of the crowds.

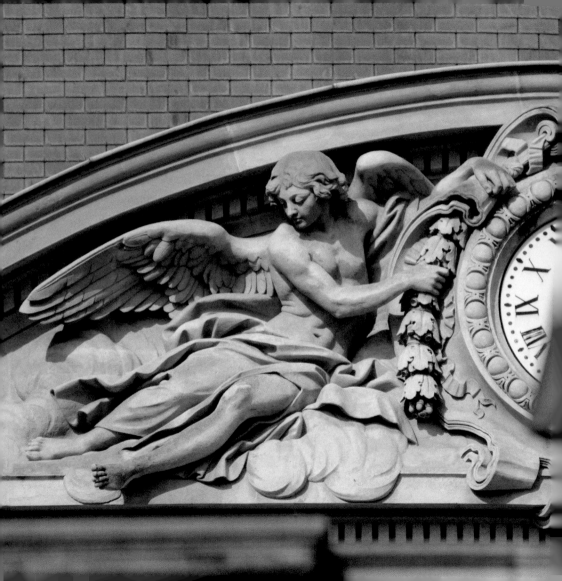

The Angels of the Duc d'Orléans
(1763)

✦

Conseil d'Etat
1, place du Palais-Royal, 1st arr.
Métro: Palais Royal

High upon a Palais-Royal building, today the site of the State Council, Augustin Pajou's duo of masculine angels floats gracefully around an elaborate garlanded circular clock. But the timepiece was not always the centerpiece of the crescent pediment.

The Palais-Royal, originally the Palais Cardinal, was completed by architect Jacques Lemercier in 1639 as the Paris residence for Cardinal Richelieu, chief advisor to Louis XIII. He bequeathed his beautiful home to the king and upon his death it became known as the Palais-Royal. By the 1660s, it had become home to all the descendents of the Duc d'Orléans.

In 1763, following a fire at the palace, Augustin Pajou, one of the finest sculptors of his time, was invited to decorate a new façade under architect Moreau-Desproux. Pajou had trained at the School of the Royal Academy and later in Italy, where he studied architectural décor. The motif of winged *génies*—the term for angels used in civic settings—was very much in vogue. Pajou's *génies*, which he also created for the Palais de Justice, bear his distinctive visual codes: uncovered knees; legs in movement; lifelike, serene faces; and sumptuous drapery. Supremely graceful, they seem to have flown in on the billowing clouds spilling over the pediment's

edge. These elegant angels originally carried the heraldry of the dukes of Orléans: three fleurs-de-lis with a *lambel*, the horizontal bar with pendants. The coat of arms, in the circle now occupied by the clock, would reign over the elegant mansion for more than eighty years.

Then political tides would eventually turn: Louis-Philippe II of Orléans, chosen to lead the July Monarchy of 1830, would be forced to abdicate when Louis-Napoléon III became president of the Third Republic. The ducal crest was scraped off the façade in 1848 and the sturdy clock put in its place. Since 1875, the palace has been the seat of the Conseil d'Etat, the highest administrative jurisdiction of the French government. But the stone angels remain, as if to moor the clock, which might otherwise sail away without them.

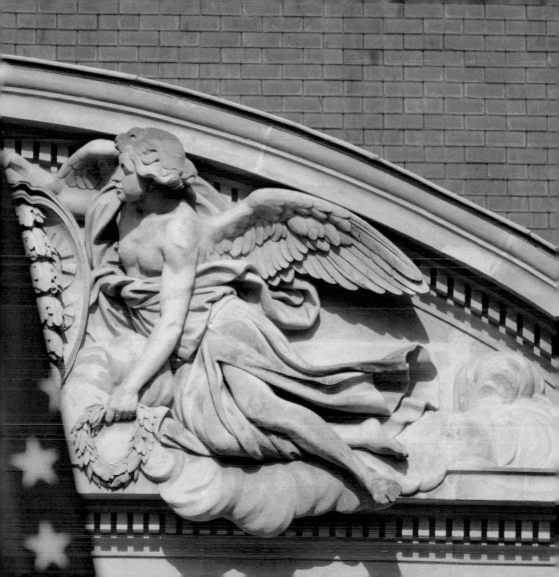

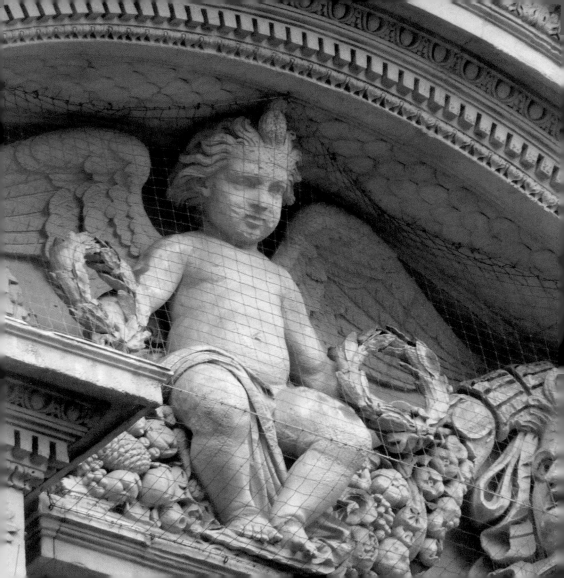

Molière's Angel
(1844)

✦

Fountain Molière
Corner of rue Molière and rue de Richelieu, 1st arr.
Métro: Pyramides, Palais Royal

We die only once, and for such a long time.
—Molière

The great 17th-century actor and playwright Jean-Baptiste Poquelin, better known as Molière, is the first citizen to have a monument dedicated to him in Paris, thanks to a national subscription instigated by the Académie Française. Until then all monuments were dedicated only to sovereigns. Designed by architect Louis Visconti, it was erected in 1844, just across from where Molière used to live at 40, rue de Richelieu. In addition to his statue, a fountain was constructed—not indispensable to his glory but a nice touch welcomed by Parisians.

James Pradier chiseled the pudgy stone angel, more formally called a *génie*, the French term for an angel used in a civic setting. Presiding over the monument in an intricate crescent niche, he clutches laurel wreaths in tribute to France's master of satire and farce. The cherub's seat is draped with a rich garland of cornucopia, flanked by dramatic masks epitomizing comedy and tragedy.

Bernard Seurre portrayed the playwright in bronze, seated, meditating on his latest work. Serious Comedy and Light Comedy,

personified by Pradier in marble, are dreamy muses posed languidly at Molière's feet, gazing up admiringly and holding scrolls engraved with titles of his most famous plays. On the lower level, water pours through four little lions' head spigots into a semicircular basin.

Molière's final exit from the stage of the Palais-Royal on February 17, 1673 was fittingly dramatic: coughing and hemorrhaging from tuberculosis during the performance of his ballet-comedy *Le Malade Imaginaire* (The Hypochondriac), he was carried to his home on rue de Richelieu where he died just after the final intermission. As an actor, Molière was initially refused burial on consecrated ground but the pleas of his widow Armande moved King Louis XIV to allow interment in the parish cemetery of St. Eustache. Today he rests in Père Lachaise Cemetery.

The Angels of the Louvre
(1855)

✦

Musée du Louvre
Rue de Rivoli entrance, 1st arr.
Métro: Palais Royal

Silhouetted against the sky above the Louvre, trios of angels celebrate the glory of the Second Empire. In 1852 Napoléon III laid the first stone of what came to be known as the "new Louvre," reviving the great Renaissance project of Henri IV to extend the Louvre palace, connecting it with a then-extant château in the Tuileries garden.

Work began in the austere, classical style of architect Louis Visconti, but his sudden death in 1853 led to the appointment of Hector Lefuel. The buildings would now reflect Lefuel's more opulent taste, with a lavish sculpted embroidery of pediments, roof armatures, *mascarons* (little masks), and cornices. Three pavilions remained to be decorated. Enter the bad boy of Romantic sculpture, Antoine-Augustin Préault.

His work, in spite of its poetic expressiveness, had been rejected by the official art salon for almost fifteen years. Rebellious and insolent, Préault had alienated the powerful jury which could make or break an artist's career by referring to it as the "reptiles' lodge." But talent will out, and he acquired loyal friends such as the eminent architect Jean-Baptiste Lassus.

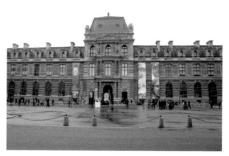

Lassus was in charge of the restoration of Sainte-

Chapelle, and wrote Lefuel a persuasive letter hailing Préault as "one of the leading artistic lights of our times" yet "ready to be clear in his mind of the ideas that you would wish him to communicate." After complex negotiations, Préault was contracted to design allegories of the arts and sciences for the rooftop crown of the Pavillon de la Bibliothèque, site of the imperial library. In a fantastic tour de force, Préault created virile, mini-Michelangelo-style angels, standing in dynamic contrapposto pose, each surrounded by a duo of companion angels.

The central angel on the left alludes to Mathematics, as he twirls his sash in a perfect parabolic arc; angels at the base twist upwards to gaze at him. An angel with a lyre portrays Music, while another, as Architecture, unscrolls a parchment plan across his lap. The dramatic mask of Theatre rounds the angle; a spherical astrolabe denoting Astronomy garnishes the plinth.

On the right, a brawny angel symbolizing Physics holds a crown in witty praise of Archimedes' experiment in buoyancy to test the gold content of Hiero II's crown. He triumphantly waves a palm branch—the medieval symbol for Grammar—in his other hand, while Geometry, a grinning angel, sits playing with a compass and his angelic buddy, Painting, is at the ready with palette and brushes. The fine feminine profile medallion on the plinth speaks of Sculpture.

An 1857 critic lauded Préault's *génies*—the term for angels on civic buildings—as "having nothing of that charming preciousness of those of the 18th century; they are strong and dense children... they dare to have muscles and stand out in vigorous contours against the sky."

This captures Préault's spirit exactly: "I adore fire, movement, freedom, and I try to lift myself from the mud to the stars." Préault received the Cross of the Legion of Honor in 1870; he died in 1879 and rests in Père Lachaise cemetery.

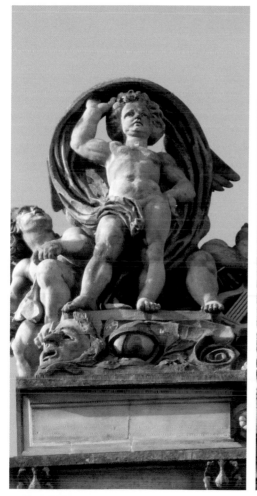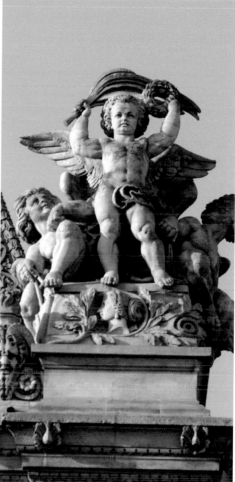

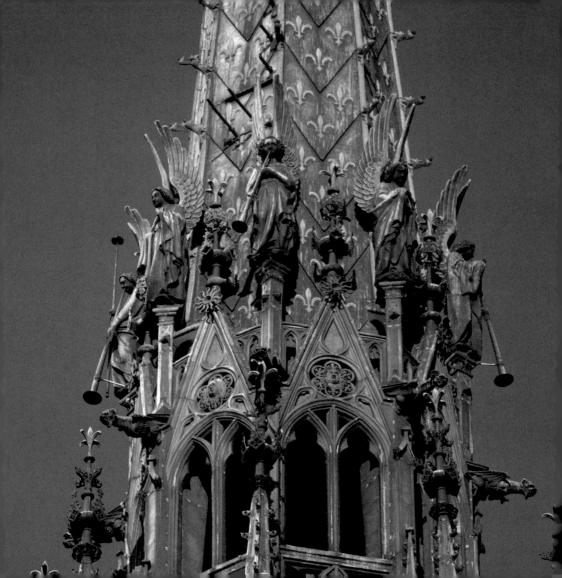

The Angels of Sainte-Chapelle
(1855)

✦

Sainte-Chapelle
Ile de la Cité, 1st arr.
Métro: Cité, St. Michel

In 1835, the beautiful medieval Sainte-Chapelle on the Ile de la Cité was in a state of rack and ruin. The Gothic jewel, commissioned by King Louis IX in 1241 to hold precious relics acquired during the Crusades, including the crown of thorns, had been desecrated during the Revolution by angry mobs who saw it as a symbol of both royalty and religion. Statuary and furniture had been destroyed or stolen, and its elegant steeple, which had been replaced twice over the centuries due to fires, was now gone. It would take the dream of an idealistic young architect, Jean-Baptiste Lassus, and the work of an exceptionally gifted sculptor, Adolphe-Victor Geoffroy-Dechaume, to return Sainte-Chapelle to its former glory.

That year, Lassus had submitted to the annual Salon—the state-sponsored Parisian exhibition of painting and sculpture—a proposal to completely restore Sainte-Chapelle. He won a second-class gold medal, and work on the monument was approved to begin in 1836; it would continue for almost twenty years. As principal collaborator

with the senior architect, Lassus would later commission Geoffroy-Dechaume to create a series of eight angels to adorn the spire.

Geoffroy-Dechaume had contributed to the restorations of Chartres and Notre-Dame, and immersed himself in the medieval spirit, carefully studying the artifacts in Paris's newly opened museum of medieval art, the Musée de Cluny. In addition, he was sent by Lassus to Picardy to visit the 13th-century cathedral of Amiens and the church of St. Ricquier to study their angels for inspiration and for veracity of detail.

Four angels of the Sainte-Chapelle steeple hold the instruments of the Passion, used during the trial and execution of Christ. In the Middle Ages they were called *les armoiries de Dieu*—the coat of arms of Christ: the lance and the sponge that was dipped in vinegar, the whip of the flagellation, the cross, and the crown of thorns. They are interspersed with angel musicians blowing the medieval tenor shawm, a long trumpet which Geoffroy-Dechaume exaggerated in length, perhaps to create an elegant counterpart to the angels' long tapered wings. Sculpted in stone, the angels are androgynous adults dressed in long gowns; the feathers of their wings are striped with gold to harmonize with the gilded detailing of the gabling and the fleur-de-lis motif of the steeple that they surround.

Lassus designed the 33-meter steeple and its infrastructure in cedar wood in the style of the 15th century, when Sainte-Chapelle was last reconstructed. The framework is a structural tour-de-force, until then never executed in the 19th century, and perhaps never attempted since the 16th century. The steeple and the angels were completed in 1855 in time for the Exposition Universelle and the visit of Queen Victoria. The steeple was highly praised for its technical virtuosity, and the angels for their scrupulous elaboration of detail and for their beauty.

The Angel of St. Germain l'Auxerrois

(1861)

✦

Church of St. Germain l'Auxerrois
2, place du Louvre, 1st arr.
Métro: Louvre-Rivoli

A stunning figure set against the sky, looking upward to heaven, such is the angel created by Pierre-Jules Cavelier for the church of St. Germain l'Auxerrois. Immense wings curve back gracefully in repose as the angel holds an unfurled banner evoking the scriptures.

St. Germain l'Auxerrois, founded in the 7th century and rebuilt several times until the Renaissance, is a sturdy testament to all the trials and tribulations a building can suffer and still remain standing. It was ravaged during the age of Enlightenment, its medieval stained glass windows replaced by clear panes, its walls whitewashed to cover the despised colorful Gothic style, and its spire and bell tower demolished. Closed and profaned during the Revolution, the church was converted alternately into a gunpowder factory, a fodder storehouse, a printing office, and a police station. Severely damaged by antiroyalist riots in 1831, it was slated for destruction, but saved and restored under King Louis-Philippe.

In 1859, St. Germain l'Auxerrois

was again imperiled: Minister of State Achille Fould wanted it torn down. Dilapidated buildings surrounding it had been demolished and the ancient church with its Renaissance façade, left standing on its own, looked sad and derelict, particularly in contrast to its magnificent neighbor across the road, the Louvre Palace.

But Baron Haussmann, Commissioner of Paris under Napoléon III, refused to destroy the old church. As a Protestant, he feared criticism should he agree to its removal: the bell of St. Germain l'Auxerrois had sounded in the night of St. Bartholomew's feast, August 24, 1572, when thousands of Huguenots—French Calvinist Protestants—were assassinated by Catholics, in one of the darkest episodes of the wars of religion. Instead, he appointed Jacques Hittorff to design buildings for a new town hall for the northern point of the site, to be inspired by the church's silhouette; the bereft church would now be integrated into an architectural complex. Hittorff created a virtual replica of the Renaissance façade of St. Germain, and Theodore Ballu was commissioned to construct a flamboyant Gothic-style belfry to stand between the two edifices, with adjacent walls and doors at the base giving access to leafy squares.

The angel designed by Cavelier in 1861 was another new addition to this very old church. He is positioned midway on the balustrade over the archway nearest the church. Cavelier had spent four years in Italy as winner of the Prix de Rome and returned imbued with the influence of antiquity and the Italian masters. His curly-haired angel in contrapposto pose straddles the centuries with elegant aplomb. By coincidence or by design, Cavelier takes up the motif of the church's porch keystone—a small angel with banner in flight—and metamorphoses it into a standing masculine figure holding a banner, a touch of the Renaissance for a church that had been reborn.

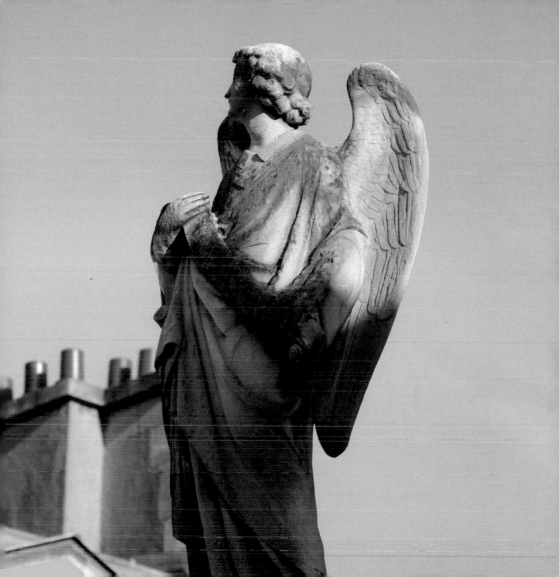

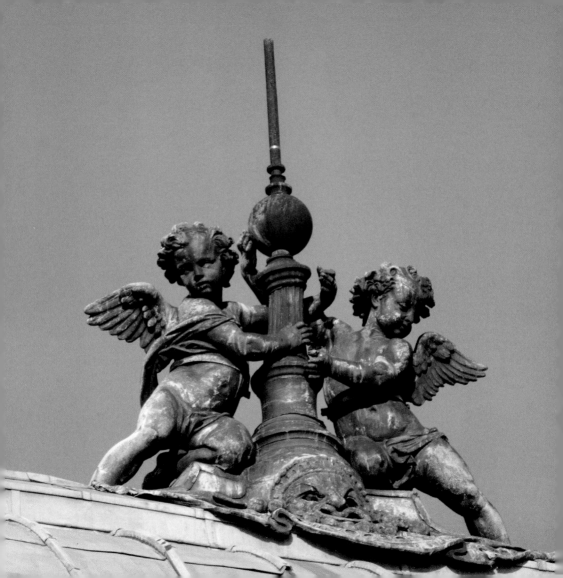

The Lightning Rod Angels

(1862)

✦

Théâtre du Châtelet
2, rue Edouard Colonne, 1st arr.
Métro: Châtelet

Quite possibly the most charming and helpful angels in Paris, this pair of cherubs arrived on the Théâtre du Châtelet rooftop in 1862, wrapping their arms gently around a lightning rod.

The theatre itself was designed by architect Gabriel Davioud, in neo-Renaissance style. Davioud borrowed freely from the great Renaissance architect Andrea Palladio's Palazzo della Ragione in Vicenza, with its arcaded ground floor and upper loggia. The receding second story is punctuated with *oculi*—eye-shaped windows—and crowned with a keel-shaped roof.

Pairs of angels, with their curly hair and muscular bodies reminiscent of Michelangelo's style, crouch on both the eastern and western façades of the building and hoist a lightning rod. A dramatic mask curves over the roof's edge, forming a graceful base for the sculpture and recalling the thespian arts.

We owe the invention of the lightning rod to the ingenuity of Benjamin Franklin, who in 1752 discovered that the destructive electrical charge of lightning could be diverted from people and buildings by placing a metal

33

rod on an elevated surface attached to a wire that would channel the current into the ground. By the 19th century, the lightning rod had become an important safety fixture incorporated on churches and other large buildings, and was often designed to be a decorative motif as seen here on the theatre. Various metals can be used for lightning rods; here, the angels and the rod are lead.

The Théâtre du Châtelet, originally named the Théâtre impérial du Châtelet, has staged eclectic programs since its inception. The works of virtuosic French composers such as Berlioz, Bizet, and Saint-Saens were first performed here, and Tchaikovsky, Mahler, and Strauss came to the theatre to direct their works. The stage version of Jules Verne's *Around the World in Eighty Days* ran for more than 2,000 performances over sixty-four years. Nijinsky and Pavlova danced here in Diaghilev's Ballets Russes in 1909.

The theatre, which seats 2500, now features musical comedies, operas, classical and jazz concerts, and dance recitals.

Napoleon's Angel of Victory
(1875)

✦

Place Vendôme, 1st arr.
Métro: Tuileries, Pyramides, Opéra

All religions have been made by men.
—Napoleon Bonaparte

Among the most delicate of the angels of Paris is a diminutive winged victory poised atop a globe grasped by Napoleon Bonaparte in one of the most elegant squares in Paris, the place Vendôme.

Victory—*Victoria* in Latin and originally *Nike* in Greek—is the goddess of strength, speed, and victory, both in battle and in peaceful competition. Lauded in epic poems and depicted in vase painting as far back as the 8th century BC, a temple to Nike is still standing on the Acropolis in Athens. The Romans decorated monuments and altars with statues in her image to commemorate military victories throughout the empire. But Victory's persona changed in AD 325 when the emperor Constantine converted to Christianity and had the pagan deities follow suit: the goddess became an angel. Her powers to protect and glorify melded perfectly with the new religion; her palm branch became a symbol of

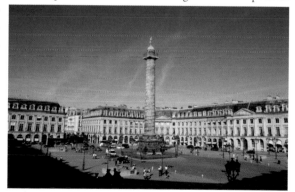

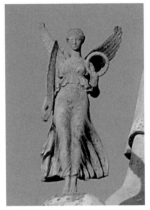

triumph over death and her laurel wreath a heavenly halo.

Under Napoleon, however, glorious symbols from antiquity were revived; the Christian angel reverted to her pagan character as goddess of victory, a subliminal endorsement of the emperor's military prowess. As such she appears on the 44-meter column in the center of place Vendôme that was erected to celebrate his army's triumph at the Battle of Austerlitz. Antonin Chaudet created the original 1810 version of Napoleon dressed as Caesar, crowned with a laurel wreath, holding a sword in one hand and the globe bearing the winged victory statuette in the other.

When Napoleon fell, so did the statue, toppled by the allies in 1814 but later replaced in 1833 by Louis-Philippe with Napoleon dressed as corporal. Dismayed by what he considered to be an undignified effigy of his uncle, thirty years later Napoléon III commissioned a copy of Chaudet's emperor in toga and sandals in its stead. Pulled down and thrown into the Seine during the Paris Commune of 1871, it was fished out of the river, restored, and put back at its post in 1874—but the little winged victory had gone missing. Authorities turned to the talented Antonin Mercié for a new interpretation.

Mercié's 1875 winged victory is steadfast, but graceful. Long-necked and finely limbed, her empire-waist gown clings to her body and seems to sway in the wind. He depicts her as a *kore*, a young girl in Greek. *Kore* statues typically stand up straight with one foot slightly in front of the other, and are often depicted with their arms held close to their sides, or with one arm lowered—as here, where she delicately holds a palm branch. The other arm is raised, bearing the victor's laurel wreath against a foil of V-shaped wings.

His merging of a realistic style with Renaissance inspiration won Mercié prestigious commissions, both in France and abroad, many with patriotic themes, such as the statue of the Marquis de Lafayette in Washington, D.C., and the Francis Scott Key monument in Baltimore.

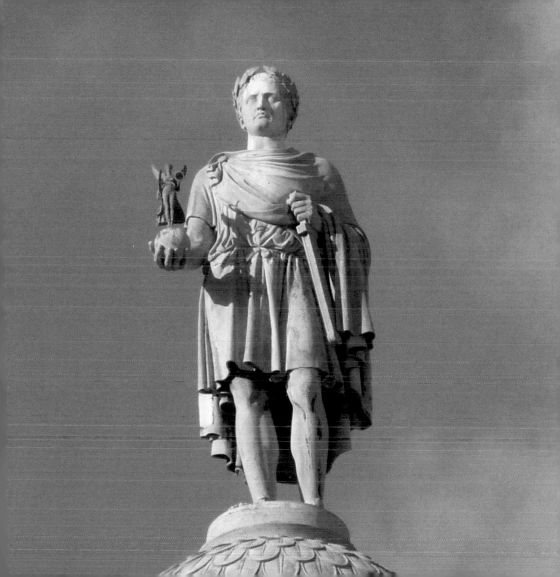

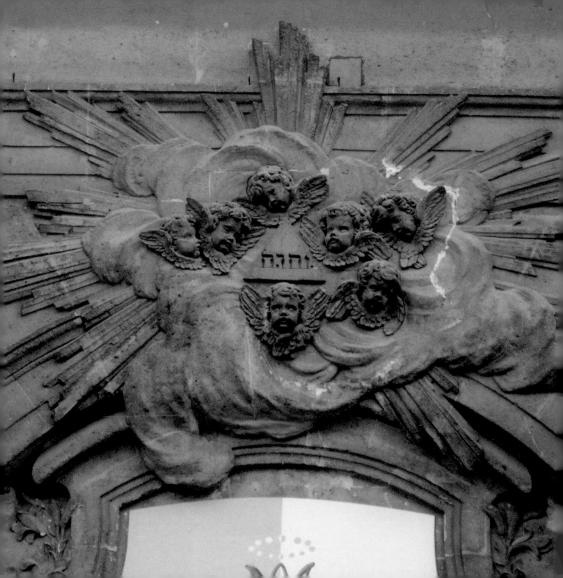

Angels of Glory
(1740)

✦

Basilique Notre-Dame des Victoires
7, place des Petits-Pères, 2nd arr.
Métro: Bourse

Winsome angels' heads tilt in all directions, clustered around a tetragrammaton above the curved portal of this extraordinary church, originally founded as the convent chapel of Augustinian monks in 1629. Louis XIII laid the first stone and dedicated the church in gratitude for a recent victory, the capitulation of the seaport city La Rochelle, wrested from Huguenot control in 1628.

Construction would last for more than a century, interrupted by war, the death of the king, and the building of the Val-de-Grâce. Notre-Dame des Victoires was finally completed in 1740 by Jean-Sylvain Cartaud, an architect known for his sense of grandeur and noble simplicity.

Cartaud appointed sculptor Charles Rebillé to design the *gloire*, or glory, a motif commonly used in 18th-century sacred art, represented by an open sky with winged cherubs, usually grouped around a tetragrammaton, a triangle in which is inscribed the name of God (He Is, in biblical Hebrew, using consonants only, because it was never to be spoken). The asymmetrical arrangement of the angels' heads set against swirling clouds is typical of the then-new Rococo style; the shooting rays

laid in straight, flat lines form a spectacular backdrop. Rebillé also created the royal coat-of-arms, decorated with wings, flags, laurel branches, and palms, which adorns the church's pediment.

During the Revolution, the convent's 40,000-volume library was destroyed and its chapel closed. It initially reopened as the offices of the national lottery; later it housed the stock exchange before being returned to its original religious vocation in 1809. As if being rewarded for its travails, Notre-Dame des Victoires is today famous for the miracles, conversions, and religious apparitions that have occurred there. Its interior walls are lined with thousands of ex-votos, small plaques engraved with grateful words for answered prayers. St. Thérèse of Lisieux came to worship here as did Mozart, when he lived in the nearby rue du Sentier.

Long the destination of pilgrims, Notre-Dame des Victoires received the honorific title of minor basilica from Pope Pius XI in 1927.

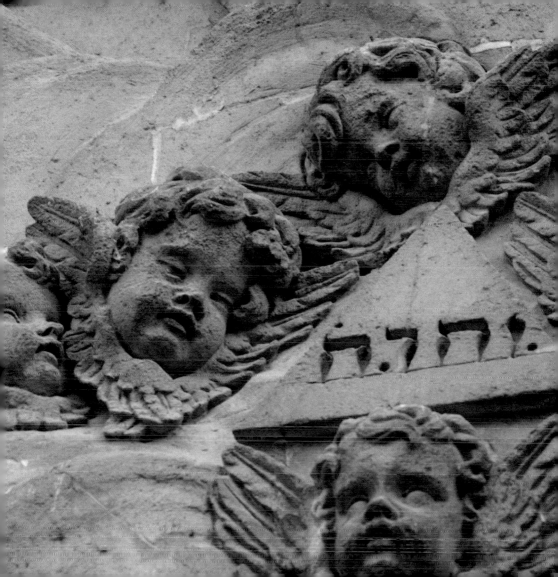

The Angel and the Dove
(circa 1830)

✦

66, rue Greneta, 2nd arr.
Métro: Etienne Marcel

I t seems quite natural that an artist specializing in industrial architectural decoration would be inspired to design a delightful scene of a dove alighting upon the hand of a smiling angel for the entrance door panel of an apartment house. These two happy winged creatures—the dove a symbol of love and peace, the angel with its association of protection—impart a sense of harmony to all who pass through the door.

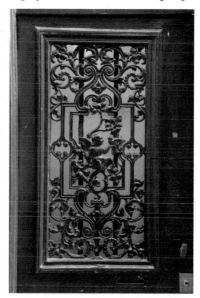

Cast-iron door grills such as this were sold from the 1830s through the 1850s. Here, the angel and dove panel, with its detailed latticework pattern of leaves, fruit, and flowers, provides secure protection for its glass backing, allows for the passage of light, and creates a whimsical welcome to the building.

The rue Greneta was opened in the 12th century under Philip Augustus, who enlarged its central market and built a shelter for its merchants. It extends from the 2nd to the 3rd arrondissement, leading from rue St. Martin in the Marais to the lively market street of rue Montorgueil in Les Halles.

il quatre cens et

The Angels of Nicolas Flamel
(1407)

✦

51, rue de Montmorency, 3rd arr.
Métro: Rambuteau, Etienne Marcel

Be not forgetful to entertain strangers: for thereby some have entertained angels unawares.
—Hebrews 13:2

A lovely stone house on a quiet street in the Marais once provided room and board for poor itinerant peasants who came from the provinces to plough and work the nearby fields. In exchange for a meal and a beer at the ground-floor tavern, and a room on the upper floors, they had a simple obligation to fulfill, engraved in stone directly above the entrance: "We men and women laborers living at the porch of this house built in the year of grace 1407 are requested to say every day a paternoster and an ave maria, praying God that His grace forgive poor and dead sinners."

It was a charitable gesture on the part of the talented and industrious Nicolas Flamel, a sworn juror who gave legal consultations, owned a bookstore, and, as a scrivener, copied and illuminated manuscripts. Flamel had set up shop nearby where he taught his trade of copying prayer books, hymnals, and texts. He married a wealthy widow, Dame Pernelle, like himself, a devout Catholic; they lived simply and dedicated themselves to philanthropy. Together their fortunes grew thanks to astute real estate speculation.

And perhaps, also, to a shared passion for alchemy: with precious

secrets gleaned from his library of ancient texts, Flamel claimed in 1382 that he had transformed mercury into gold. (It's as an alchemist that he has been immortalized in J.K. Rowling's *Harry Potter and the Sorcerer's Stone.*)

But the real magic he worked was as a draftsman. It is believed that he designed his own tombstone, today part of the collection of the Musée National du Moyen Age in Paris. The quartet of angel musicians carved in stone panels flanking the doorway of 51, rue de Montmorency appears to be of the same hand, echoing Flamel's stylistic touches of curly hair and moon-shaped haloes. Despite the passage of the centuries, a cheerful wit endures in the angels' faces with their wide eyes and jaunty smiles set off by feathery arched wings.

During the Middle Ages, angel musicians were believed to express the divine harmony of the cosmos. Wind instruments, such as the angel's Provençal pan flute—illustrated in perfect authenticity, complete with shoulder strap—evoked divine power. Strings, such as the angels' hand-held harp, psaltery, and three-stringed mandolin, suggested the heavenly harmony. All four are small, portable instruments, as if chosen for ease of flight.

Dressed for a church choir, the angels wear medieval clerical robes with cowl collars, long full sleeves, and narrow wrists, and are set in a finely drawn framework of beveled columns—a wonderful document of early 15th-century architecture. The artist's fastidious pursuit of truth in details heightens the endearing charm of the angel panels.

Nicolas Flamel lived to the prodigious age of 88. He bequeathed several hospitals and charitable foundations, as well as his many houses and their income, to the Church of St. Jacques-la-Boucherie, for the distribution of alms to the poor. The nearby rue Nicolas Flamel intersects with the rue Pernelle, named for his wife.

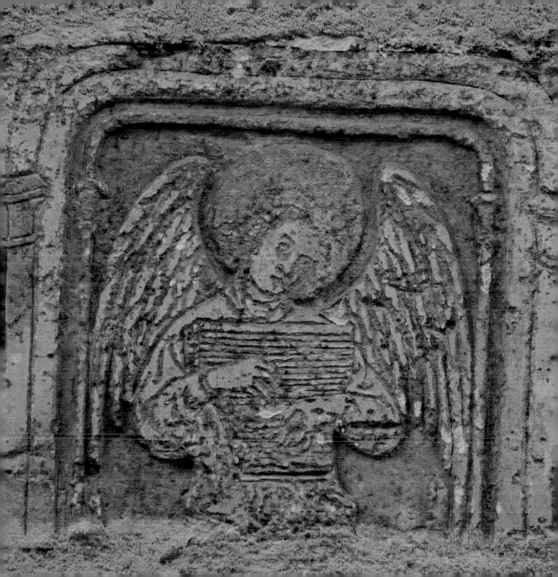

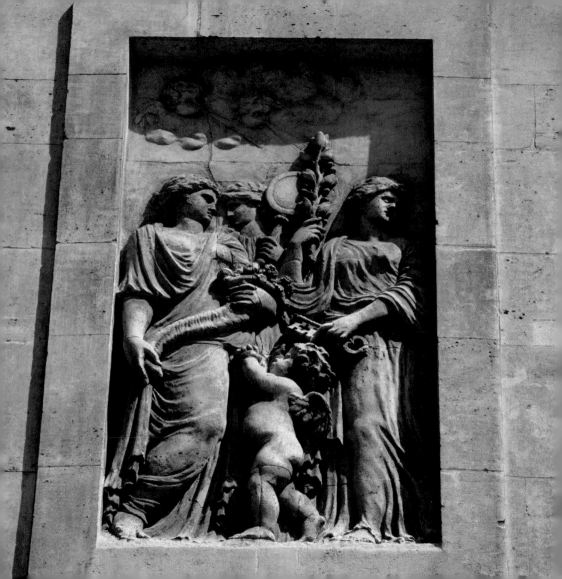

The Angel of Allegorical Love
(1654)

✦

Musée Carnavalet
Rue des Francs-Bourgeois at the corner of rue de Sévigné, 3rd arr.
Métro: Chemin Vert, St. Paul

Just around the corner from the entrance to the Musée Carnavalet, high on an otherwise plain wall, lurks a low-relief sculpture of enigmatic figures. It is Gerard Van Obstal's quartet of allegories, with messages in stone true for all time.

Since antiquity, sculptors represented abstract ideas in the form of humans or animals, or with symbols. The use of allegory in art reached its peak in the 17th century, largely due to the success of Caesare Ripa's *Iconologia*, an encyclopedic collection of imagery of "virtues, vices, passions, arts, humors, elements and celestial bodies." Based on Egyptian, Greek, and Roman emblems, it was published in Rome in 1593. Once its French translation appeared in 1643, the fashion for allegory flourished in decorative art. The book became a rich source of inspiration for orators, poets, artists, and sculptors such as Van Obstal.

In the Carnavalet panel, Abundance, dressed in a long, generously draped Grecian-style gown, carries a long horn of plenty bursting with fruits and flowers. Prudence, like Abundance, is portrayed

49

in profile; they look directly into each other's eyes. Her mirror bids the viewer to examine one's defects in order to know one's self; it also symbolizes the anticipation of the future. Prudence is often shown in tandem with Abundance, as abundance is considered the result of exercising prudence.

Peace, a modestly dressed woman, holds an olive branch. Her enormous key has myriad meanings: liberty, but also power and submission, as it is keys that a vanquished city surrenders to the victor. The little curly-haired angel is, without ambiguity, Love. Tender, innocent, and naked of all attributes, he reaches towards Abundance, as if seeking more.

Known in his native Flanders for his fine low-relief sculpture, Van Obstal was called to France by Cardinal Richelieu to embellish the Louvre and the Salpêtrière Hospital; he also garnered numerous clients for private homes, such as the hôtel Carnavelet.

The city mansion was built from 1548 to 1560 for Jacques des Ligneris, the president of Parliament, who had acquired a vast amount of terrain bordered by the rue Payenne, the present rue de Sévigné, and the rue des Francs-Bourgeois. He sold it in 1578 to Françoise de Kernevenoy of Brittany, whose name was unpronounceable to Parisians; it was corrupted into Carnavalet, and the mansion became known by that name.

In 1654 its new owner, Claude Boislevé, a wealthy arms dealer, entrusted architect François Mansart with the remodeling of his already sumptuous home. The buildings on the street side were raised by one floor. It was during this transformation that Mansart commissioned Van Obstal to decorate the angle of the building on the rue des Francs-Bourgeois.

In 1866, the city of Paris bought the buildings to house its historic collections; the Musée Carnavalet, an outstanding museum dedicated to the history of Paris, opened to the public in 1888. It is one of the oldest *hôtels* in the Marais.

The Architect's Angels
(1685)

✦

Hôtel Libéral Bruand
1, rue de la Perle, 3rd arr.
Métro: St. Paul, Chemin Vert

Dancing on the pediment of a luxurious city mansion in the heart of the Marais, two little boy angels drape garlands of flowers around an oculus as fruits, flowers, and foliage tumble from giant cornucopias at their feet. It was a time of luxury and splendor under the Sun King, Louis XIV, and the intricate, abundant low-relief sculpture is redolent of its time.

The *hôtel particulier*, or private home, built in 1685, was the property of Libéral Bruand, an exceptionally gifted man who had been appointed as architect to the king at the age of 28, having proved himself on projects such as the chapel of the Salpêtrière hospital and the Notre-Dame des Victoires basilica. A master of French classical style, Bruand was an advocate of a streamlined uncluttered architecture concerned with solidity, utility, and mathematical harmony.

The most famous of his works is Les Invalides, built from 1670 to 1674 to house aged and ailing soldiers. Bruand used the frontage of the Invalides' Honor Courtyard as a template for his own home, adapting design details such as the unusually long, lavishly ornamented triangular pediment spread across the central corps of the building. For the Invalides, it would be adorned with Mars and Minerva, deities of

war; here, it is a duo of winged cherubs with floating drapery and thick locks flying in the wind.

Bruand's mansion was built in 1685, a time when classical architecture began to take on a lighter, baroque turn; a whiff of unruly passion perturbs orderly reason. The little angels, by an unknown ornamentalist sculptor, are a charming visual caprice and a frivolous departure from sober stability.

Today a private residence, it is hidden from view by a large wall that surrounds the inner courtyard. The beautiful angels bring a joyful touch to the neighborhood.

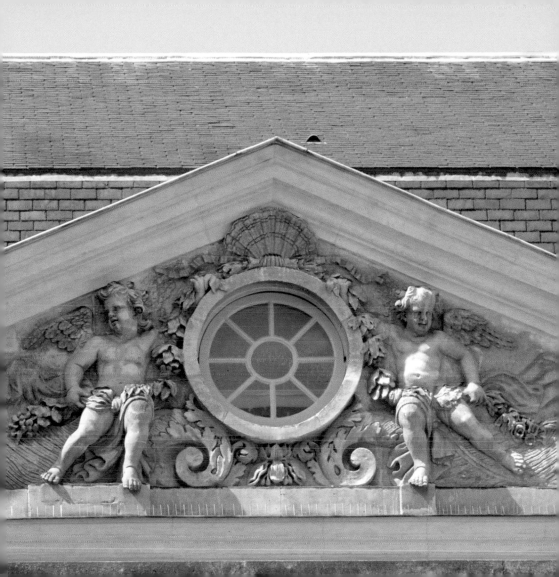

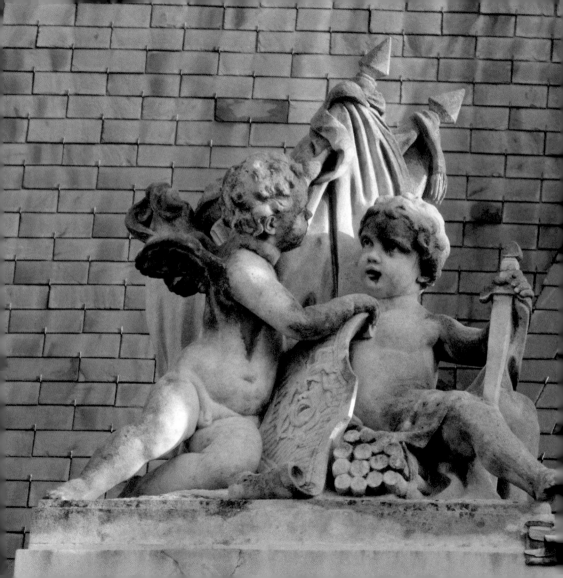

Angels for a Princess
(1708)

✦

Hôtel de Soubise
60, rue des Francs-Bourgeois, 3rd arr.
Métro: Rambuteau

Entering the splendid courtyard of the hôtel de Soubise, one feels a sense of harmony born of the elegant arrangement of double-colonnaded porticos and manicured lawns leading to one of the most beautiful mansions in Paris.

As the gaze wanders over the stately façade, adorned with dashing statues personifying the seasons on the first story, and the female figures Glory and Magnificence lolling on the pediment slope, the spectator is captivated by Robert Le Lorrain's charming duos of angels and cherubs playing at the pediment's edge. They are acting out the allegories of War and Commerce, common themes in 18th-century architectural décor.

One angelic boy props up fringed standards as he unscrolls a banner engraved with the head of Medusa, the symbol of Minerva, goddess of war. His dirty-faced companion sits upon a *fascine*—small sticks of wood bound together for strengthening ramparts and making parapets—as he grasps a sword. Across the way, a curly-haired angel leans forward gracefully as his playmate raises a caduceus, Mercury's emblem signifying com-

merce and negotiation, attached to his flowing cape. The background sheaf of palm leaves has, from the time of antiquity, symbolized victory.

Le Lorrain had set up his studio in the nearby rue de Meslay soon after returning from Rome, where his talent had won him six years as a *pensionnaire du roi* at the Palazzo Mancini to study works from antiquity and the Renaissance. His stay was curtailed by a chest ailment—common to sculptors, in constant contact with stone and marble dust—but once back in Paris, commissions poured in for statues of angels, saints, and mythological figures for cathedrals, churches, and the château of Versailles.

The hôtel de Soubise angels, their lively poses casting a dramatic play of light and shadow, express the new Baroque style that Le Lorrain had mastered in Italy. They were executed circa 1708 when the mansion, formerly the 16th-century hôtel de Clisson, was being entirely redesigned by architect Pierre-Alexis Delamair for the beautiful princess Anne de Rohan-Chabot, a lady-in-waiting at the court of Versailles, who had caught the eye of the generous King Louis XIV.

Anne's husband, François de Rohan, prince of Soubise and the lieutenant general of the royal armies, had already acquired the hôtel de Guise, just around the corner on the present rue des Archives, in 1697. It was said that the new house did not cost him much because "the king had provided the wood" (the horns of the cuckolded Soubise) and "his friends supplied the stones" (which they threw at him, figuratively speaking).

No expense was spared in the construction of the hôtel de Soubise. It was designed, as were all luxurious *hôtels* since the Renaissance, to be *entre cour et jardin*—between courtyard and garden. The lavish statuary includes yet more cherubs on the rooftop corners bearing attributes of the arts and sciences.

Today the hôtel de Soubise is the seat of the national archives and hosts exhibition rooms for the Musée de l'Histoire de France. The beautiful interior can be visited in mid-September during the annual Journées du Patrimoine, a weekend during which historic properties are opened to the public.

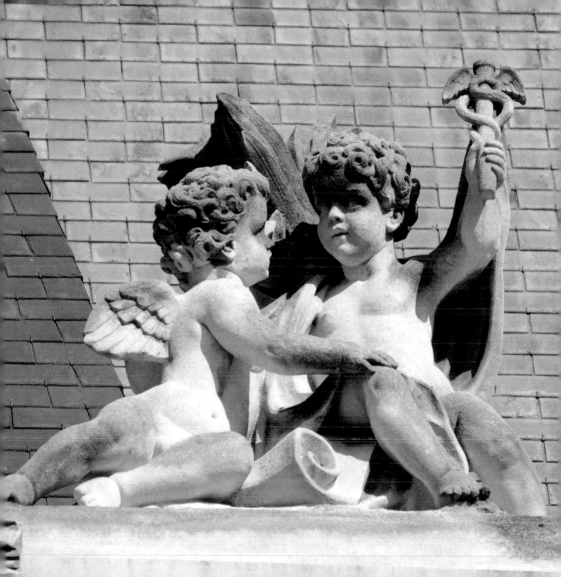

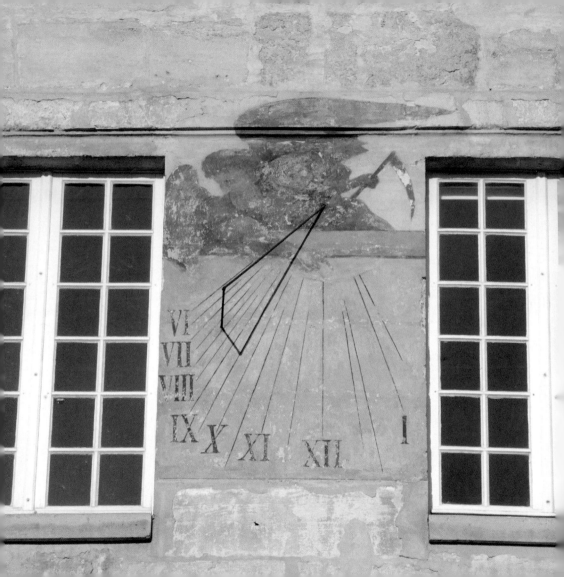

The Angel of Death
(circa 1727)

✦

45, rue des Archives, 3rd arr.
Métro: Rambuteau, St. Paul

An aged, bearded angel hovers high over a sundial on the western wall of a property once used by the Order of Mercy. Founded in 1218 in the former Kingdom of Aragon during the time of the first Crusades, its members promised to sacrifice their worldly goods, and their lives if necessary, for the ransom of impoverished Christians held as captive slaves by Moorish pirates. In 1613, Marie de Medicis granted the monks permission to set up quarters in this former convent in the Marais district. The buildings were reconstructed from 1727 to 1731; it is believed that the sundial and its unusual fresco date from this period.

The order was shut down during the French Revolution and the structure used as a prison to hold those awaiting sentencing and death at the guillotine. One can only imagine the thoughts of the condemned, counting their mortal hours while contemplating this cruel angel, an allegory for time and death. He points ominously to the first hour in a macabre reminder of the transience of life, while his raised left wing shadows the dark profile of the grim reaper stealing away bearing a scythe, symbolizing the severing and harvesting of human souls. The angel of death peers downward, searching the world below for his next prey.

Today the stately buildings have been converted into private apartments and the sundial is hidden from view by a stone wall set off by a magnificent red door.

The Lighthouse Angel
(1860)

✦

57, rue de Turbigo, 3rd arr.
Métro: Arts et Métiers

Spanning three stories at 57, rue de Turbigo, a smiling, colossal stone angel seems to silently watch over this 1860 *palais collectif*—shared palace—an attractive bourgeois apartment residence erected during the building boom orchestrated by Baron Haussmann under the aegis of Napoléon III. The goal was to aerate, beautify, and unify the capital, until then a medieval maze of dark, insalubrious, winding streets.

Extended in 1858 from the 1st arrondissement to the 3rd, ending just at the border of the 10th, the rue de Turbigo bends gently along the way, creating an oblique angle precisely at number 57. Architect Eugène Demangeat was confronted with an aesthetic dilemma: how to soften the edge of this building on a Parisian thoroughfare in a pleasing way. Emile-August Delange, a young sculptor-architect, provided an unusual solution.

While a student at the Ecole des Beaux-Arts et Architecture, Delange had participated in an 1852 lighthouse design competition. His submission, featuring an angel towering over a lighthouse, lost the contest but won the attention of the prestigious *Revue Générale de l'Architecture*, which published Delange's project along with three others, lauding them for their "poetic artistry." At the rue de Turbigo, Delange would recycle his angelic creation to fit

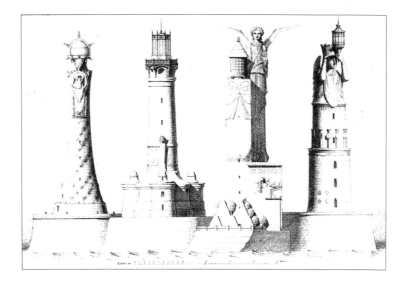

on the new building with organic aplomb.

The angel's gown, its fine pleating recalling the fluting of a Corinthian column, rounds the angle gracefully, while its enormous outstretched wings support the fourth-floor balcony. Its tassel earrings, beaded necklace, ribbon sash, and embroidered bag make him a beacon for the *passementerie*, or trimmings trade, for which the neighborhood was known. Yet in spite of its fancy detail, the angel carefully respects the strict Haussmannian building codes, which forbade the use of projecting elements. Its nine-meter body is flush with the wrought-iron grillwork, allowing clear passage of light into the apartments.

Delange's sculpture also serves as a giant advertisement for himself: *de l'ange* means "of the angel." At its post for more than one hundred and fifty years, the angel continues to radiate its eccentric charm.

The Angels of Brittany and Saintonge
(1914)

✦

Northwest corner of rue de Bretagne and rue de Saintonge, 3rd arr.
Métro: Filles du Calvaire

Tucked into alcoves under the first-floor balcony of a handsome 1914 residential building, Hiolle and Garraud's sculpted stone pairs of boy and girl angels are at the service of Bretagne (Brittany) and Saintonge. Each duo floats through the centuries bearing their heraldry aloft, in a charming allusion to a king's urban design to honor the regions of France in the capital city.

Henri IV conceived a project to create a semicircular place de France, a large square, with seven radiating streets, each named for one of the principal provinces of France, such as Bretagne, to be intersected with others bearing the names of less important provinces, such as Saintonge. The project began in 1610 in what is today the northern section of the Marais in the 3rd arrondissement, and ended the same year with the death of the king. A vestige of his plan would be renewed in 1626; new streets were named for Picardy, Beauce, Poitou, and Franche Comté. Only the corner of Bretagne and Saintonge, however, would come to be graced with angels delicately carrying shields half their size in honor of their streets' namesakes.

The use of shields dates back to the Middle Ages. Originally designed to protect warriors in

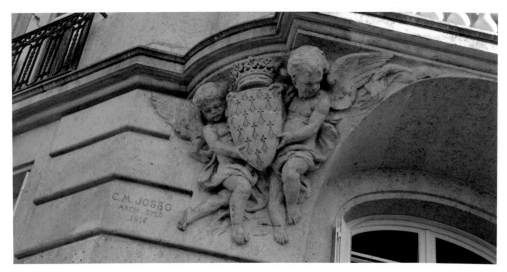

battle, they were decorated with the coat of arms of the lord or territory for which they were fighting, in order to establish the participants' identity. Their ogival shape—a straight upper border atop a pointed oval—is meant to evoke the human face. The angels' shield on the left-side niche bears a finely detailed repetitive pattern of flecks of ermine, representing the heraldry of Bretagne. It derives from the coat-of-arms of the 12th-century count Pierre de Dreux of the Duchy of Bretagne, who renounced his initial vocation as priest in favor of a career in the military; the ermine, a rare and expensive fur, was formerly reserved for the monarchy. The crown above the shield is decorated with fleurs-de-lis, a reference to the province's ties with the monarchy.

Decorating the right-side niche, angels raise the coat of arms of Saintonge, a mid-western province formerly part of the Duchy of Aquitaine, now located in the department of Charente. The bishop's miter of St. Eutrope, a 3rd-century martyr who Christianized Saintonge, is surrounded by three fleurs-de-lis, representing the Church, the royalty, and the military.

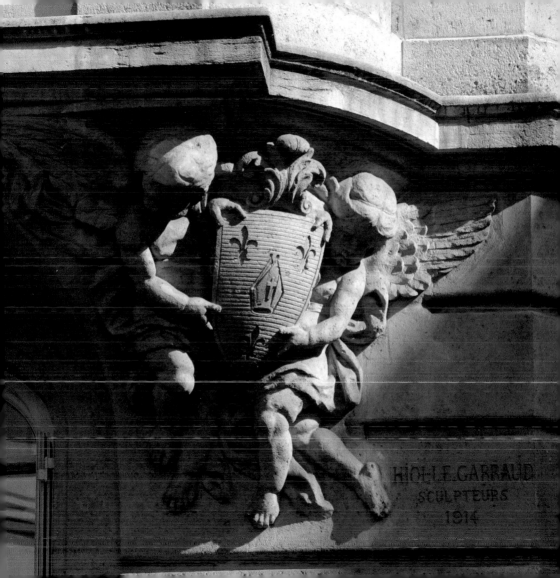

HIOLLE.GARRAUD
SCULPTEURS
1914

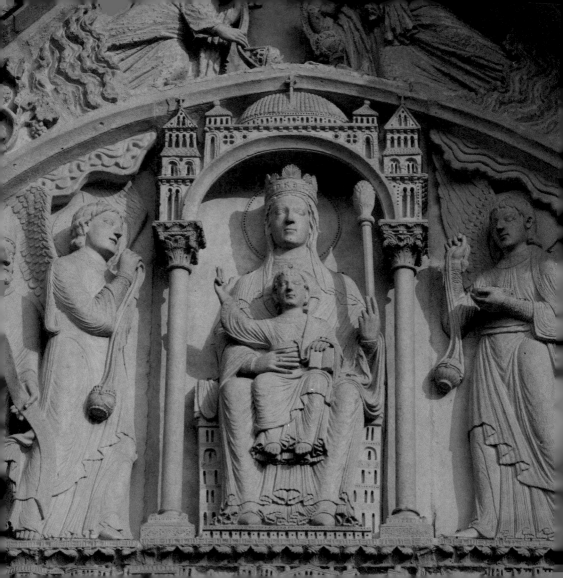

The Oldest Angels in Paris
(1146 – 1148)

✦

Notre-Dame Cathedral
Parvis Notre-Dame, 4th arr.
Métro: St. Michel, Cité

The story of the oldest angels in Paris begins on the façade of the Notre-Dame cathedral, in the very center of the city on the Ile de la Cité. Two smiling, censer-swinging angels dressed in intricately embroidered mantles and tiered gowns enliven the half-moon-shaped tympanum of the St. Anne door—something of a misnomer, as almost all the stories sculpted in stone above the doorway concern the Virgin. Designed from 1146 to 1148 for the smaller St. Etienne cathedral that formerly occupied the site, the tympanum was saved and put aside when St. Etienne was razed in 1160 to make room for the grander Notre-Dame, dedicated to the Virgin.

Sweeping forward as their robes fall in a calligraphy of fantastical, finely chiseled waves, wings unfurled against curvy clouds, the angels perfume the Virgin and Child with incense, a symbol of the prayers of the faithful rising up to heaven. Lively forms portrayed in asymmetrical poses, these celestial figures are depicted in a naturalistic style derived from the art of Roman churches.

St. Germain, bishop of Paris, stands on the left and King Childebert kneels on the right. As founders of the original cathedral, they are honored in the tympanum. A scribe in the corner

records the king's donation. In an echo of Byzantine icons, the Virgin, the highest figure, dominates the tympanum. Enthroned in a rigid, formal pose, she is seated atop a model of the holy city of Jerusalem while the domed canopy above her suggests the Hagia Sophia of Constantinople, both sites of the then-ongoing Second Crusades. Wearing an elaborate crown and holding a scepter, she presents the Christ Child for veneration.

The doorway of the new cathedral, finally ready to be installed in 1210, proved to be much larger than that of the old cathedral. And so the old tympanum was expanded. A scroll of foliage encircles it; figures of an angel, a lamb, and Christ of the Apocalypse close the meeting of the arches.

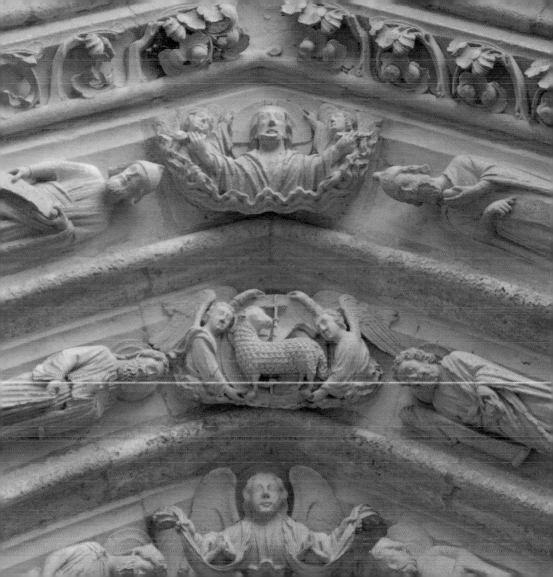

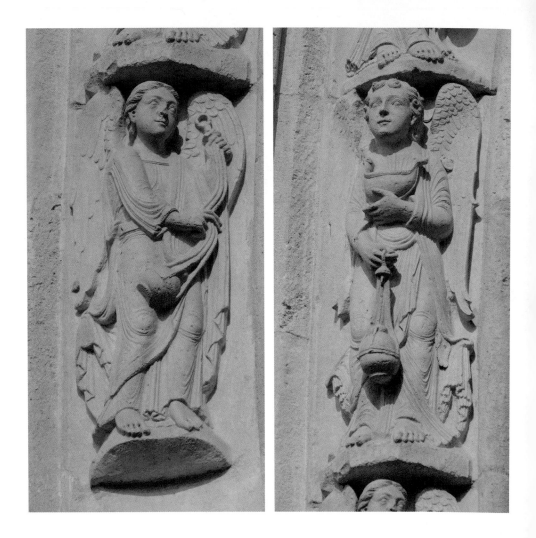

The Angels of the Arches
(circa 1210)

✦

Notre-Dame Cathedral
Parvis Notre-Dame, 4th arr.
Métro: St. Michel, Cité

L ike the notes of Gregorian chants sung inside the cathedral, the angels of the St. Anne portal ascend and descend the arches, swinging incense-burners in a rhythmic beat. Inspired by the dense ornamentation of illuminated manuscripts, their anonymous sculptors crammed every niche of the arches with sets of angels lined up next to rows of Old Testament prophets and patriarchs.

Barefoot, dressed as altar servers in surplices, these diminutive statues resemble the children of the cathedral school of which Notre-Dame was so proud. The swirling folds of their long tunics cling to their bodies as the hems turn up in a whimsical train, as if lifted by the wind. Each angel is unique in expression and in pose and even their inventive hairstyles differ—some have long locks tucked behind the ears; others, curls twirled into little horns on the temples; still others wear braids. Every detail is meticulously and affectionately noted.

The angels' 13th-century censers also are factually authentic, with pointed lids, flat bases, and punctured holes to allow the scent to permeate the church. Their triple chains are attached to large round hooks, so that the good little angels can fly into the sacristy to hang them up once Mass is over.

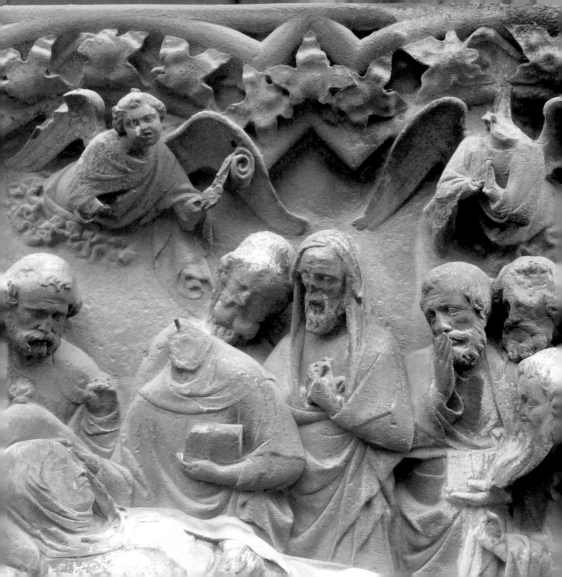

The Broken Angels
(circa 1325)

✦

Notre-Dame Cathedral
Rue du Cloître Notre-Dame, 4th arr.
Métro: St. Michel, Cité

The angels on a sculpted panel of Notre-Dame's northern façade, wings chopped, bodies decapitated, and hands amputated, bear witness to the savagery of the French Revolution, yet are laden with unforgettable poignancy. Their faces and gestures convey the immense sorrow felt at the Dormition, or "falling asleep" of the Virgin. The term dormition is used by the Church instead of the word death because of its teaching that Mary's soul and body were reunited after her death, before her Assumption to heaven. Neither the Dormition nor the Assumption are events that appear in the Bible, but are found in 2nd-century apocryphal books.

Hovering over the grieving apostles, the angels embody the anguish of the loss of a loved one. Carved in stone, gilded and painted, as were all the statuary of Notre-Dame, vestiges of the red ground and gold remain visible on the angels' wings and on the heads of the apostles.

The panel is unsigned and undocumented; the 14th century was a time of belief in the nobility of a group project. We can almost hear the gentle tapping of the artisans' chisels resonating through the ages, transforming a block of stone into a permanent work of art, transcending decoration to become the vestment of the cathedral.

But in 1789 comes the thud of the axes of furious Revolutionary crowds; they too have their own steadfast convictions. Angry at the power and the wealth of the Church—then the largest landowner in the country, amassing revenues from its tenants as well as enormous income from tithes—in a few brief seconds this beautiful work of ecclesiastical art would be mutilated for eternity.

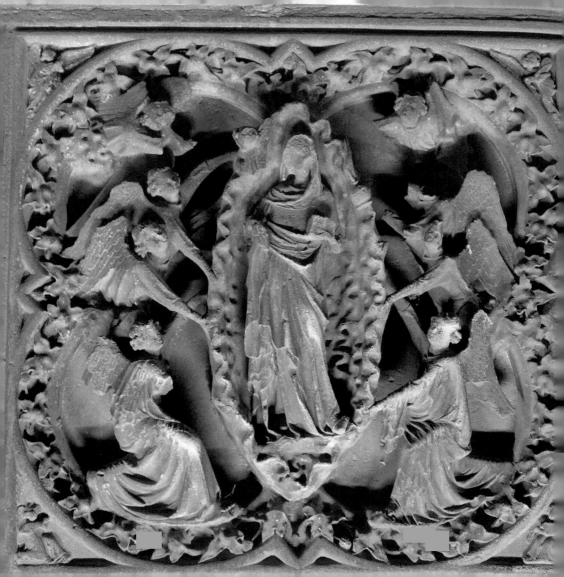

Angels of the Assumption
(circa 1325)

✦

Notre-Dame Cathedral
Rue du Cloître Notre-Dame, 4th arr.
Métro: St. Michel, Cité

A ngels in flowing robes, their arms overlapping in a graceful latticework design, gently lift the almond-shaped mandorla of Virgin Mary in this scene evoking her Assumption into heaven.

The beautiful stone panel is one of a series of seven low-reliefs dedicated to the Virgin. Vestiges of gold still cling to the panel, once entirely painted and gilded, today almost seven hundred years old. Tiny, finely chiseled musician angels fill the spandrels of the frame around a quadrilobe of stylized leaves, typical of the refined graphic vocabulary of this period of Gothic art.

The particularly feminine angels, three aloft on either side of the wavy cocoon, and two posed above, suffered severe damage at the hands of Revolutionary vandals, who hacked away at ecclesiastical sculptures in savage retaliation against the power and the authority of the Church in France. The delicate image of Mary, wearing flowing gown and *maphorion*, the long veil which hid the hair and lent a modest grace to the figure, was also mutilated, yet the scene of the Assumption remains an exquisite small masterpiece.

Although the Bible makes no reference to the Assumption, Church tradition evolved from apocryphal writings that hold that the Virgin Mary ascended bodily into heaven. In 1950, the Assumption was declared dogma by Pope Pius XII. The feast of the Assumption is celebrated on August 15.

The Artistocrat's Angels
(1660)

✦

47, rue Vieille du Temple, 4th arr.
Métro: St. Paul

T he argument as to the sex of angels is clearly resolved in the case of the beautiful *angelots* —baby angels—balanced on a couple of scowling, truncated lions stationed on double panels on the majestic carriage door of the *hôtel particulier* of Vicomte Amelot de Bisseuil. During the time of Louis XIV, this was considered one of the most beautiful homes in the Marais, the neighborhood of court aristocrats, and the nouveau riche and famous.

Amelot de Bisseuil, a *maître des requêtes*, fit this profile perfectly. A "master of requests" was chosen from among the best judges and members of the Parliament to provide royal oversight of the judicial system and serve as private counsel to the king. A noble title such as vicomte was bestowed upon those who could afford the privilege of purchasing the costly office.

De Bisseuil's position at court would have led to his meeting Pierre Cottard, an architect of the king. De Bisseuil hired Cottard to design his mansion, and chose sculptor Thomas Regnaudin, also under appointment to the king, to create the door and its decoration. Regnaudin had proved his talents in decorative sculpture at the Louvre, the château de Fontainebleau, and for the fountains of Versailles.

For the massive oak door, Regnaudin em-

ployed themes typical of the Baroque period: feminine deities of Fame and Victory for the stone pediment, cameos of the mythical grimacing Medusa on the lower panels, and pairs of earnest, chubby-faced winged cherubs, here serving to hold de Bisseuil's elegant monogram in place on the door's central panels. The finely carved, lavish ornamentation flaunts the owner's rank and prestige.

The building itself, a fabulous affair of over 1700 square meters of living space with balustraded balconies and courtyards richly adorned with statuary, was declared a Monument Historique in 1924.

The Rococo Angels
(1733)

✦

Presbytery of the Church of St. Merry
76, rue de la Verrerie, 4th arr.
Métro: Hôtel de Ville

Sloped playfully along the graceful bowed window arch of the presbytery of the Church of St. Merry, two stone angels captivate passersby with their light-hearted charm as they hold emblems of the legendary saint, a 7th-century abbot of Autun.

With his little wings open, and sash flying in the air, a smiling angel clutches a chain with two

huge keys, evoking the early hermitage of the abbot Merry—derived from Médéricus—when he came to Paris to live in a hut near a chapel dedicated to St. Peter, the keeper of the keys to the heavenly kingdom. Another carefree angel poses on the ledge with a crosier, the abbot's staff. Between them, a chiseled heart in a wavy shell recalls the relics of St. Merry, stored in the church until its destruction during the Revolution. The adorable angels' curvy forms, asymmetrical poses, and insouciant gestures embody the light, fanciful style known as rococo, inspired by the sinuous shapes of rocks, shells, and lichen, in vogue during the early 18th century.

The first church dedicated to St. Merry was built around the corner on the rue St. Martin, at the site where he was believed to have lived and died. As the population of the district grew,

subsequent churches were built until the present church was erected in the mid-16th century. In 1733, renovations were in order, and the church wardens chose architect Jacques-François Blondel to design a new presbytery, the residence of the parish priest, to be attached to the side of the church on the rue de la Verrerie.

Sebastien-Antoine Slodtz was the fortunate winner of the commission for the presbytery's ornamental design and sculpture. Decorative work on interiors and exteriors of churches was highly coveted; being easily accessible and visible, it served as a showcase to potential clients.

The fluted pilasters topped by garland-entwined vases below the angels, also carved by Slodtz, add a secular touch to the presbytery's doorway. The building's entrance also served laypersons who rented the upper floors.

Slodtz was a descendant of a celebrated artistic dynasty begun by his father, who had come from Antwerp to settle in the French capital; four brothers had also trained as artists and sculptors. Noted above all as a draftsman, Slodtz created all the decorations for the festivities, spectacles, and ceremonies—known as *les Menus-Plaisirs* (the small pleasures)—for Louis XV at Versailles.

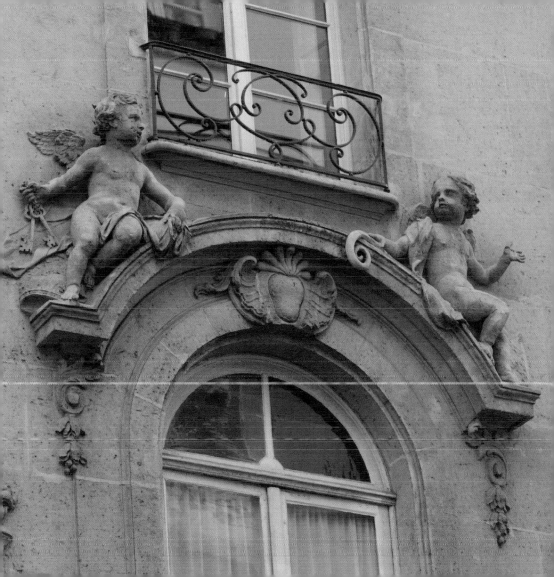

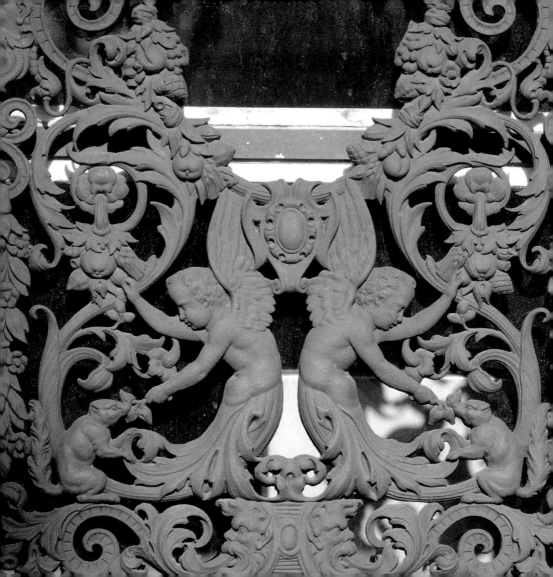

Angels and Squirrels
(circa 1830)

✦

78, quai de l'Hôtel de Ville, 4th arr.
Métro: Pont Marie

I n a graceful gesture, puffy-cheeked boy angels pluck fruits and nuts from trees to feed hungry squirrels on this lovely cast-iron door panel. The scene is in the bountiful Renaissance style, popular in the 1830s—the top half of the ornamental grill teems with child satyrs, rabbits, a lion's head, curlicued borders, stylized flowers, and more squirrels scampering towards a fruit basket.

The cast-iron industry developed first in England, at the Darby foundry of Coalbrookdale in 1709. France adopted the new technique slowly over the 18th century, limiting its use first to domestic objects and tools, and gradually producing cast-iron fountains, statuary, and chimney firebacks. The 1820s would see the first production of cast iron used for architecture, in balconies and grillwork. Its boom years were from 1830 to 1850, coinciding with a period of renovation and reconstruction in France. Decorative cast iron allowed for the marriage of art with industry.

The fanciful grillwork of angels and squirrels serves as a protective screen against its door's glass panel, yet, beyond the needs of practicality, careful attention is given to every detail. The angels and squirrels on each side are not mirror images—each side has slight differences—a credit to the designer's originality. This design is particularly attractive with its hollowed oval center, allowing the light to pass through the door and illuminate the inner hallway.

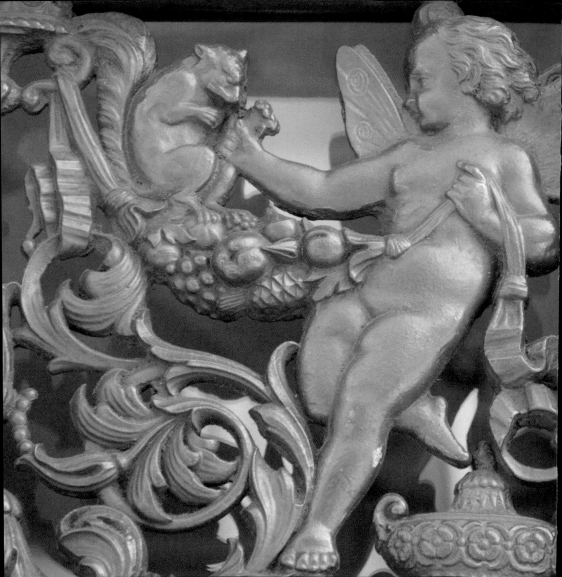

The Knight's Angels
(1833)

◆

4, rue du Pont Louis-Philippe, 4th arr.
Métro: Pont Marie

A fanciful pastiche of angels, satyrs, genies' lamps, birds, flowers, and fruit surrounds the proud Renaissance knight depicted on the cast-iron panel of an otherwise modest entry door of this apartment building near the banks of the Seine.

The style is typical of the eclecticism in vogue during the reign of Louis-Philippe, the self-proclaimed King of the French from 1830-1848. Known as the bourgeois king, he presided over the rise of the industrial age in France. It was a time of the democratization of art; in this case, new techniques of melting iron made possible the mass production of decorative door panels. In the unusual scene here, smiling angels gaily cling to ribbons while offering nuts to eager squirrels crouching on garlands of cornucopia.

The rue du Pont Louis-Philippe was laid out in 1833, as an extension of the rue Vieille du Temple to lead to the bridge, Pont Louis-Philippe, which crosses over to the Île-Saint-Louis. The apartment houses were built at the same time.

The Angels of the Seal of Paris
(1876)

✦

9, place de l'Hôtel de Ville, 4th arr.
Métro: Hôtel de Ville

A duo of mischievous angels with fetching smiles poses above the sober façade of an administrative annex to the Hôtel de Ville—the Town Hall—across the square. Between them, the angels gaily display the seal of Paris, crowned by a curved band of crenellated towers evoking the medieval ring of fortifications that once surrounded the city.

Featuring a boat on the Seine, the seal has been the heraldry of Paris since the early Middle Ages, and stylized in a dozen different ways throughout the centuries. The current version most resembles the blazon of 1556, created by order of the Provost of Merchants of Paris: a narrow band of pointed fleurs-de-lis, symbol of the French monarchy, tops the image of a triple-masted vessel sailing downstream on the curly-waved current of the Seine, flowing as it does, from east to west.

The *marchands d'eau* (water merchants) were the most powerful guild of Paris; their origins dated back to its very first inhabitants, a Celtic tribe, the Parisii, who gave the city its name. *Par* meant oar in ancient Celt, and the Parisii were great boat builders and navigators. They settled on the Ile de la Cité circa 250 BC and by the time of Roman emperor Tiberius' reign in the first century, they were already a recognized corporation who had raised their own temple to Jupiter (where Notre-Dame now stands).

The water merchants received privileges under

Louis VII in 1170, and by 1210, Philip Augustus had ceded them control of the Seine, the life-blood of the city. They alone had the right to transport commodities and goods to the port of Paris. No merchant who did not belong to the corporation could navigate this important trade route without being led by one of its members or by a representative. It was a most lucrative monopoly; the river route presented at that time the easiest and safest system of transport, given the inadequacy and poor condition of the roads, compounded by problems of security.

The most natural symbol for this commerce was the riverboat. In sealing their private and public documents with a cachet representing a boat, this emblem became well known to the general citizenry and was eventually adopted as the city's seal. The fleur-de-lis would be added in 1358, a sign that the dauphin Charles was considered the protector and master of the symbolic barque. Since then, the fleurs-de-lis have accompanied the ship of Paris, except during the First Empire of Napoleon Bonaparte and from 1848-1853, when they were replaced respectively by three bees and by a field of stars.

The coat of arms is today found on many Parisian buildings, including the office of the mayor of each arrondissement, train stations, bridges, and schools. Here, the angels sloping on a scrolled pediment hung with fruit garlands add a touch of levity to the seal.

The story of the origin of Paris is also recalled by 767 informational panels that were installed in 1992 on streets in front of monuments. Designed by Philippe Starck, and marked "Histoire de Paris," they feature the design of a stylized ship and are in the shape of boatman's oars.

The Winged Man
(2006-2009)

✦

Tour St. Jacques
Square de la Tour St. Jacques, 4th arr.
Métro: Châtelet

O n the southwest corner of the summit of the Tour St. Jacques—the St. James Tower—presides a kneeling, beaming angel with an unfurled scroll. Sometimes called a winged man, the angel is the symbol of St. Matthew, one of the four evangelists of the New Testament. The icons of the other evangelists are there also: the eagle (John), on the northwest angle; the winged lion (Mark), on the northeast; and the winged ox (Luke), on the southeast. Christian tradition has long associated the authors of the Gospels with the four "living creatures" described in Book of Revelations.

Matthew is author of the first gospel, which recounts the genealogy of Jesus, from father to son, from Abraham through his incarnation as Christ; it is believed that for this reason he is the only evangelist to be depicted as a boy-angel rather than an animal.

The Tour St. Jacques is a bell tower without bells and bereft of its church, the St. Jacques-de-la-Boucherie, which was built and enlarged from the 12th through the 15th centuries. The construction of the 52-meter tower was begun in 1509, and completed and added to the church in 1523. Its rich,

intricate façade carvings in flamboyant Gothic style reflect the wealth of the patrons, the whole-sale butchers of the nearby Les Halles market. Originally located nearby, the church served as a point of departure for the St. Jacques de Compostelle pilgrimage, the Way of St. James, to the Santiago de Compostela Cathedral in Spain, where the remains of the apostle St. James are believed to be buried.

After being confiscated from the Church and reclassified as national property during the Revolution, St. Jacques-de-la-Boucherie was dismantled and sold stone by stone; only the bell tower survived, thanks to the intervention of the architect Giraud, who had included a clause in the bill of sales that forbade its demolition. The City of Paris acquired it in 1836; it was later restored by architect Theodore Ballu, who added an arcaded base to raise the tower to its previous stature. All the statues were resculpted at that time, including that of St. Jacques, the namesake of the church, on the western pinnacle.

In 1856, the tower was installed in the Square de la Tour St. Jacques, one of Paris's first public gardens. The smiling, curly-haired St. Matthew angel was restored again, along with the companion statues, from 2006 to 2009.

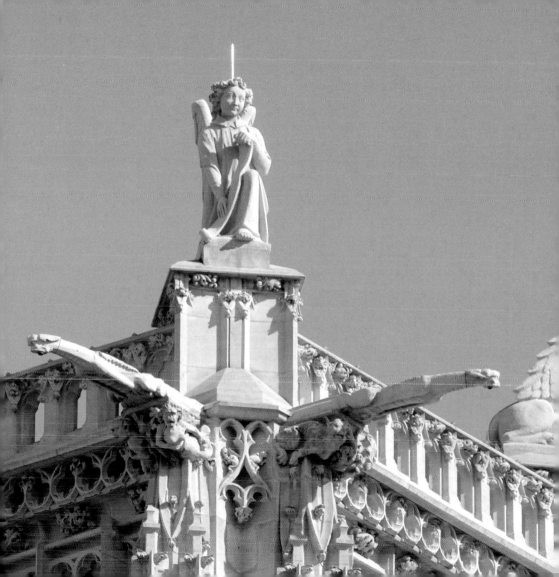

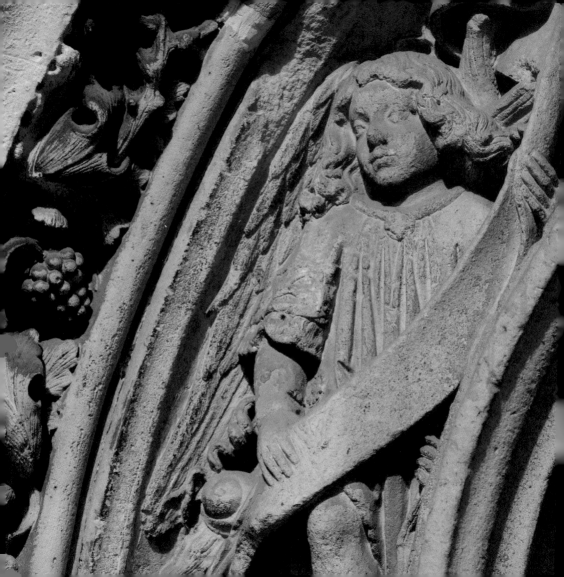

A House Built by Angels
(circa 1500)

✦

6, place Paul Painlevé, 5th arr.
Métro: Cluny-La Sorbonne, St. Michel

An exotic but festive welcoming committee of young boy angels, snake-eating dragons, and snails nibbling on stems crowds into the beveled door frame of the former pied-a-terre of the abbots of Cluny-en-Bourgogne. Lush bunches of grapes and scrolling vine leaves twine through the décor in a picturesque allusion to the vineyards of Burgundy.

The angels look like earthy little peasant children, unhaloed and barefoot, but the cruciform broaches adorning their smocks and long, feathery wings tucked back reveal their true identity. Long wavy hair cascades to their shoulders as the angels unfurl ribbon-like banners, their expressions oddly serious. The lavish, exuberant archway gives a measure of the importance of the mansion, which belonged to the most powerful monastic order of its times.

The Abbey of Cluny, founded in the 10th century, encompassed not only a huge international complex of buildings, but also a hierarchical, centralized organization in Church politics. The mother house in Burgundy engendered more than 1,000 monasteries in France alone. Dependencies known as priories spread all over Europe, each owing allegiance to Cluny. Elaborate celebration of the liturgy and perpetual prayer were the order's chief concerns. The abbots' prayers

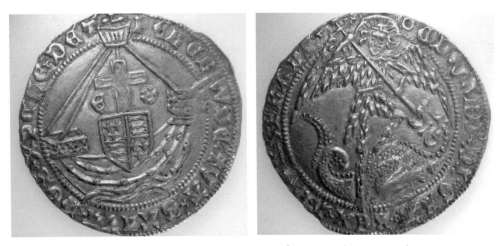

and masses for the dead became a principal source of revenue; their spiritual intercession was believed essential to attaining a state of grace. The abbey also benefited from endowments in land and donations and became one of the wealthiest monastic houses in the Western world. Their monks wore linen habits and silk vestments, and enjoyed fine foods and a prosperous lifestyle.

Around 1330, the Clunisians acquired a house in Paris adjoining the ruins of Gallo-Roman thermal baths in which to lodge visiting abbots and professors teaching theology and philosophy at the Collège de Cluny, located at the nearby Sorbonne. Work on a larger, more luxurious residence began in 1489, thanks to the arrival of angels of another kind: legacies of English monks that were paid to the abbey in beautiful gold coins, known as Angels, owing to the design on their head of the archangel St. Michael trampling on a dragon. A large part of a bequest of 50,000 Angels was dedicated to the construction, executed in flamboyant Gothic style.

Today the hôtel de Cluny houses an exceptional collection of medieval art, the Musée National du Moyen Age, and the ancient baths.

The Executioner's Angel
(1639)

✦

Hôtel de Laffémas
14, rue St. Julien-le-Pauvre, 5th arr.
Métro: Cluny-La Sorbonne, St. Michel

On a quiet cobblestone street across from a medieval church stands the vestige of a 17th-century mansion which once belonged to one of the most feared and reviled men of the reign of Louis XIII. The stately portal of the hôtel de Laffémas speaks of the prestige and fortune of its former proprietor, as well as of his unsavory profession. Curiously, an angel appears on the carved stone pediment.

Isaac de Laffémas amused himself in his youth as a poet and actor until his father, the wealthy Controller General of Commerce, had him named attorney to the Parliament of Paris. Appointed private counsel to Louis XIII in 1625, by 1639 de Laffémas had reached the zenith of his career, becoming the Civil and Criminal Lieutenant of the Provost of Paris, an impressive title derided by Parisians as the *bourreau du Cardinal*—the Cardinal's henchman. Cardinal Richelieu, the king's chief advisor, directed de Laffémas to repress any suspected plot against the royalty. De Laffémas was responsible for capital executions, and acquitted himself with zeal.

The winged cherub artfully posed over the beveled stone portal stares unabashedly at the spectator, clutching a handful of posies. In this incongruous setting, he is the nonchalant companion

to Justice, portrayed as a slouching muse in a gown of deep décolletage, distractedly swinging her scales of justice. Designed in the Mannerist style, which followed the Italian High Renaissance and was brought to France by Marie de Medicis, the figures are elongated in exaggerated poses. Form and artificiality trump rigorous depiction of anatomy: the angel's head is too big and the muse's too small.

Branches of laurel, signifying glory, and of oak, a reference to royal law, border the scene. A beaded chain tumbling at the angel's feet bears a pointed cross; the royal decoration, most likely the Ordre Protestant de Saint Jean, attests to de Lafférmas's influential position.

Such was his dark reputation that centuries later, Victor Hugo wrote of de Lafférmas in his dramatic play, *Marion Delorme*: "Devil, in my eyes I see the sinister flame of the ray of hell which illuminates your soul."

In spite of losing all his official duties upon the death of Richelieu, de Lafférmas never wavered in his loyalty to the crown.

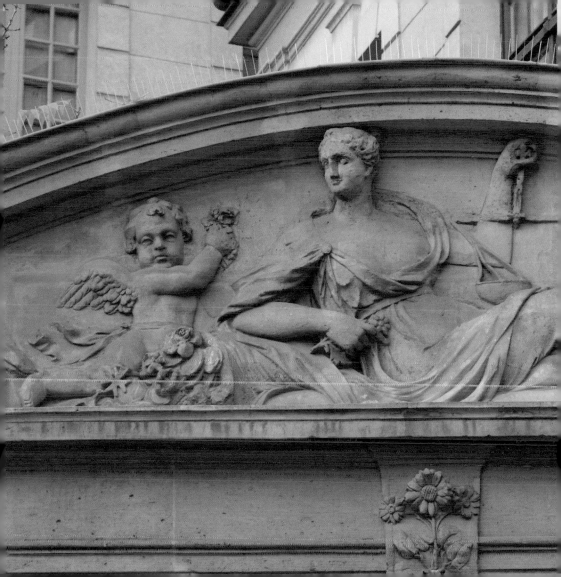

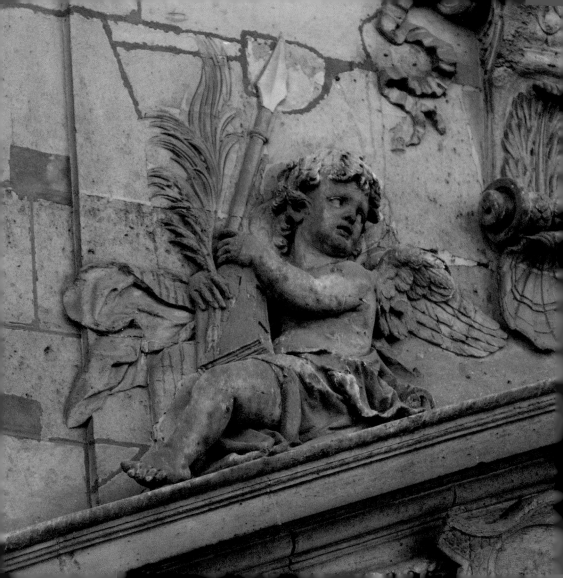

The Revolutionary Angels
(1662)

✦

Church of St. Nicolas du Chardonnet
23, rue des Bernardins, 5th arr.
Métro: Maubert-Mutualité

Over the side door of St. Nicolas du Chardonnet, two baby angels perched on the pediment ramparts were unwittingly drafted into the great social and political upheaval of the French Revolution. Finely carved in 1665 by Nicolas Legendre after drawings by Charles LeBrun, official painter to His Majesty Louis XIV, the angels epitomize the luxurious royal style, featuring flowing draperies, a lily, and a book surrounded by elegant accoutrements, including a scallop shell, ribboned garlands, a palm frond, and scrolled acanthus leaves. For more than two hundred years, one angel held a bishop's crosier, the other the keys to heaven.

St. Nicolas du Chardonnet began as a 13th-century chapel near a field of *chardonnets*, or thistles; it was named in honor of Nicolas of Myra, a 4th-century bishop from Lycia and the patron of bargemen. The church was rebuilt and modified in the 15th century and later in the 17th, when it came under the direction of LeBrun, who happened to be one of the parish wardens. A side entrance was created on the rue des Bernardins;

the beautiful sculpted oak door was installed and above it, the stone pediment with its childish angels.

In 1792, with the onset of the French Revolution and the rise of anti-clerical sentiment, the money and property of St. Nicolas's priests were seized, an effigy of the saint disappeared from the main façade, and the pediment angels were reworked—given pikes to hold in place of the religious crosier and keys—to fit the times. The church was closed in 1795, its statues, furniture, and reliquary sold at auction as "carpentry wood;" it would not reclaim its religious vocation until 1802. Much of its property was eventually recovered or replaced, but the angels remain armed, a mirror of the church's dramatic history.

Another revolution of sorts occurred here in 1977, when members of the Society of St. Pius X, a fundamentalist international organization opposed to changes in the Catholic Church effectuated following the 1965 Second Vatican Council, expelled the parish priest during Mass and occupied the church. An eviction order mandated by the city was never implemented. The church, which uses the Latin mass exclusively, is today the principal Parisian stronghold of the traditionalist Catholic movement.

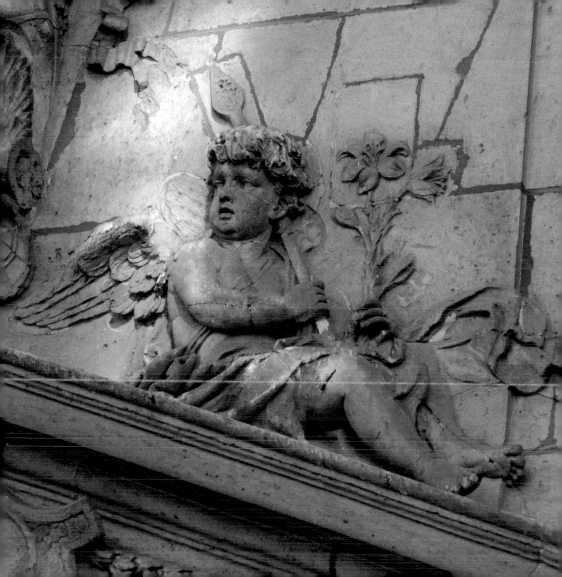

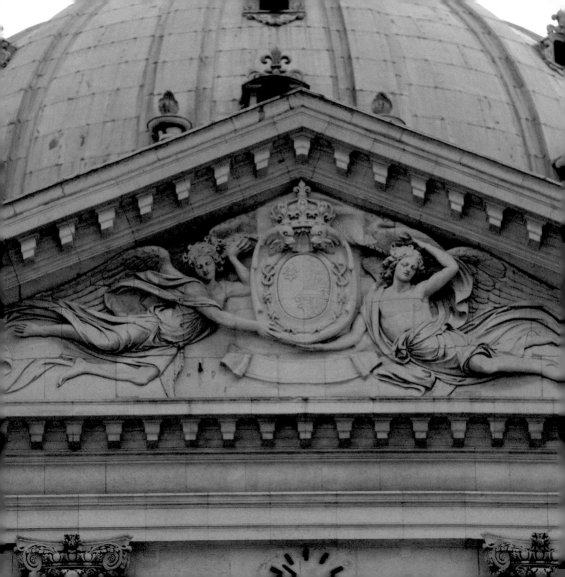

Angels and Dolphins
(1665)

✦

Val-de-Grâce
1, place Alphonse Laveran, 5th arr.
RER: Port Royal

Iesu nascenti virginio matri (Jesus was born of the virgin mother)
—Dedication of the Church of Val-de-Grâce, inscribed in gold over the main portal

Sensual angels of ethereal beauty emerge from stone through the artistry of sculptor François Anguier. Drifting languidly in a wave of lush drapery, eyes demurely downcast, hands artfully posed, their wings brushing against the triangular pediment of the church, the angels they gently lift a crowned medallion of the arms of Anne of Austria, the consort of Louis XIII. Below its crown smile a pair of curled-up baby dolphins, in a charming allusion to the French word *dauphin*, which signifies at once the aquatic mammal and the word denoting the heir to the king of France. The shell between them recalls the pilgrims who wore *coquilles* around their necks en route to St. Jacques de Compostelle, the cathedral in northwest Spain where the apostle St. James is buried. Val-de-Grâce is just off the rue St. Jacques, the road which begins at Notre-Dame, their site of departure.

Anne of Austria vowed to erect a magnificent temple to God, dedicated to the Nativity, if she were to bear a son. At the age of 36, after

twenty-two years of marriage and three miscarriages, the queen would realize her joy with the birth of the dauphin, Louis Dieudonné, "the God-given," on September 5, 1638.

Plans for a beautiful church, as well as new abbey buildings for a Benedictine order of nuns, were drawn up by the royal architect, François Mansart, during the queen's last month of pregnancy. Budget overruns would lead to Mansart's dismissal one year later; political and financial obstacles would then delay construction until 1645, when the six-year-old future Louis XIV would lay the first stone of the foundation. Louis XIII had died in 1643. The rope garland encircling the coat of arms is an allusion to the *cordon du veuvage*, a symbolic rope of widowhood. Two *lacs d'amour*—open knots—evoke the links of love and union between Anne, the widowed queen, now regent, and the her late husband; the six closed knots represent his son's age.

Although the church was achieved with small modifications under architects Lemercier and Le Muet in 1667, it is considered one of Mansart's masterpieces, a synthesis of restrained French classicism and the enlivening influence of Italian Baroque. The swaying, curly-haired angels, who were added in 1665, form a gentle counterpoint to the rigorous colonnaded façade. A gold-tipped black gate bearing the gilded intertwined A and L monogram was added in 1669. The same motif repeats in stone above the main portal.

Today the church is open for religious services and classical music concerts. The abbey buildings, used as a military hospital during the Revolution, have been converted into a library and a museum of army health services.

The Sundial Angels of the Sorbonne
(circa 1676)

✦

Sorbonne University
17, rue de la Sorbonne, 5th arr.
Métro: Cluny-La Sorbonne, St. Michel

Sicvt umbra dies nostri (Our days flee like a shadow)
—Inscription engraved on the upper cornice of the Sorbonne sundial

Two gorgeous gilded winged figures embellish the Sorbonne's magnificent 17th-century sundial. One measures the dimensions of the earth with a compass, the other holds a tablet for notation, as Phoebus Apollo, Greek god of the sun, charges ahead above them in his chariot, bringing in the new day as night retires behind him.

The sundail was commissioned by a cardinal, Armand Jean de Plessis Richelieu, and designed by an astronomer abbot, Jean Picard, for the Collège de Sorbon, begun as a school of theology in 1257. One might think that the sundial would have a spiritual inspiration more befitting its setting, but the year of its creation was 1676, the height of the reign of the self-proclaimed Sun King, Louis XIV. During the duration of his reign, religious references in art were usurped by images of mythological gods who figure in the constellation of the sun and its planets.

The sundial's figures have all the allure of masculine angels. Their unfurled wings, tilted heads, and angled bodies are elegantly composed as they turn towards the globe,

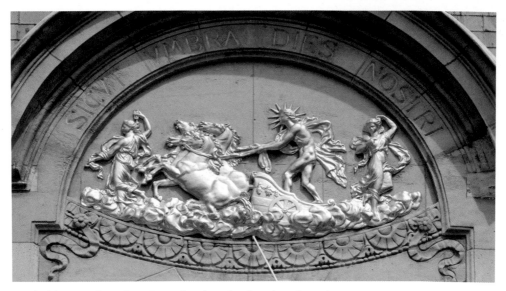

one lushly attired in a luxuriant robe, the other bared to the waist.

A tall rectangle measuring 3.90 x 1.40 meters, the sundial is engraved and painted in gold. The ten hourly markings in full lines begin at the arc of a circle and end at the sides or at the base; half-hours are indicated in dotted lines. Eleven diurnal arches are traced between lines XI and I, along with notations for the 21st of each month.

The majestic sundial was moved in 1899 when the Sorbonne was reconstructed. Now set atop the northern façade of the Galerie Robert de Sorbon, it presides fifteen meters above the ground in the honor courtyard. The date of its restoration is noted on the base. The sundial can be viewed during guided tours of the Sorbonne; contact: visites.sorbonne@ac-paris.fr

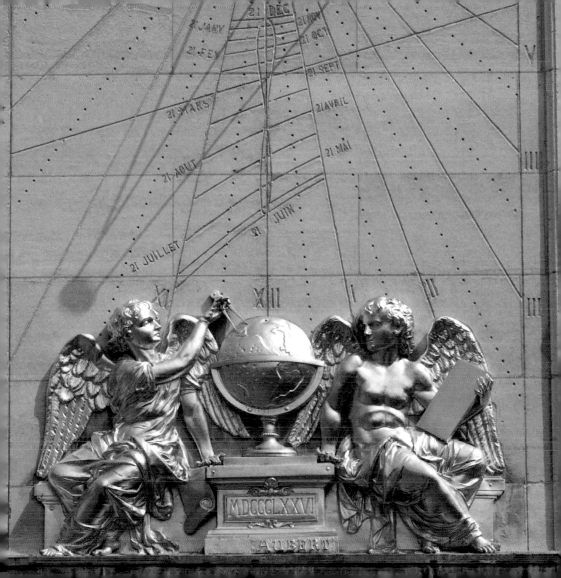

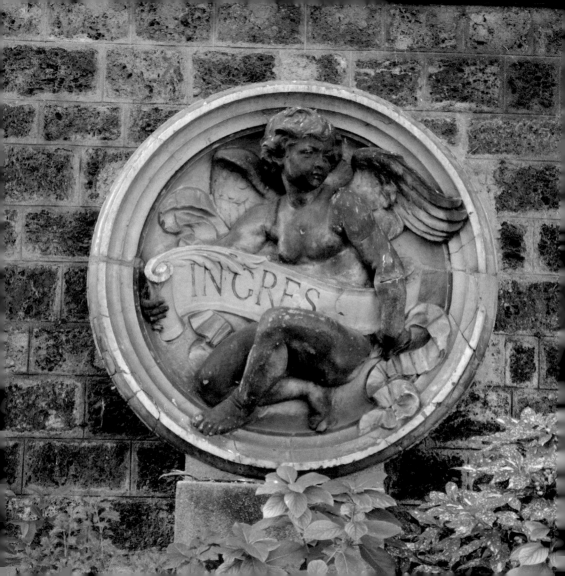

The Ingres Angel
(1889)

✦

Square Paul Langevin
20, rue Monge, 5th arr.
Métro: Cardinal Lemoine

A beautiful ceramic and stoneware angel created by Jules-Paul Loebnitz, a master of *les arts du feu*—the fire-born arts—poses on a high wall in the Square Paul Langevin, a triangular patch of greenery in the Latin Quarter. It is a vestige from the Exposition Universelle, the World's Fair, of 1889.

Loebnitz, acclaimed for his technique and artistry, was one of the top exhibitors at the Fair. Here, the extraordinary Eiffel Tower was unveiled and served as the entrance arch to visitors including Thomas Edison, Vincent van Gogh, Edvard Munch, James Whistler, and the Prince of Wales. The Ingres angel was part of a massive frieze made for the Pavilion of Fine Arts.

Loebnitz acquired a ceramic factory in 1857 from Jean-Baptiste Pichenot, who had perfected a procedure allowing for the production of large-format tiles and plaques that would be impervious to deformation and cracking under freezing temperatures. With the new technique, Loebnitz was now able to produce colorful and durable

architectural ceramics in addition to manufacturing heating elements such as wood-burning stoves and chimney firebacks. His ingenuity led to collaborations with leading architects. Commissions poured in to decorate railroad stations and the Theatre of Monte Carlo, as well as to participate in the restoration of the château de Blois in the Loire Valley.

Loebnitz's stoneware angel unfurls a banner to honor the great 19th-century neoclassical French painter, Jean-Auguste-Dominique Ingres, a seminal figure in the history of French art. In an artful pose, the angel's head, wing, and leg transgress the blue and white striped frame, giving a three-dimensional aspect to the low-relief sculpture. Fashioned in a pleasing one-meter *tondo*, or round plaque, Loebnitz evokes the style of Luca della Robbia, the great Renaissance sculptor and ceramicist who inspired him. Like the Italian master, he employs a cerulean blue background, perfectly celestial for the angel. Although worn, Loebnitz's angel has stood the test of time, beautifying the Square Paul Langevin for more than a hundred years.

The Macaron Angels

(circa 1925)

✦

Maison Keyser, Boulangerie-Pâtisserie
14, rue Monge, 5th arr.
Métro: Maubert-Mutualité

Just above this bakery on an enchanting shop sign, a pair of floating angels rain down chocolate and vanilla *macarons* from a golden cornucopia. Smiling and playful, the cherubs seem to dance amongst the clouds in a celestial blue sky.

The celebrated workshop of Benoist et Fils, which thrived for three generations between 1859 and 1940, created this panel, as well as many others throughout Paris. Specialized decorative painters, inspired by the dreamy, pastel-colored tableaux of Boucher and Watteau, worked on canvas; they were joined by skilled letter-painters working in tandem with meticulous gilders, who applied pure gold leaf to create the oval medallion and its fancy detailed border. The paintings were then covered with glass and set outdoors on the façade between the windows of the mezzanine above the shop.

The inscription, *Bourbonneux, ses macarons* refers to an acclaimed pastry chef and his famous *macarons*, sweet,

light confections of two round cookie wafers made of ground almonds, sugar, and egg whites, with a tasty filling of butter cream or jam. *Macarons* have been a favorite of Parisians ever since the Renaissance, when Catherine de Medicis' pastry chef brought them over Italy, to the delight of the court of the Louvre.

In the early 1900s, M. Bourbonneux's candies and cookies were so appreciated that even Marcel Proust wrote about them in *A l'ombre des jeunes filles en fleurs*. Bourbonneux sold his *macarons* to shops all throughout Paris, and in particular to this *boulangerie-pâtisserie*, which opened in 1925; most likely, the painted panel dates to that same year. The charming façade was given landmark status in 1984.

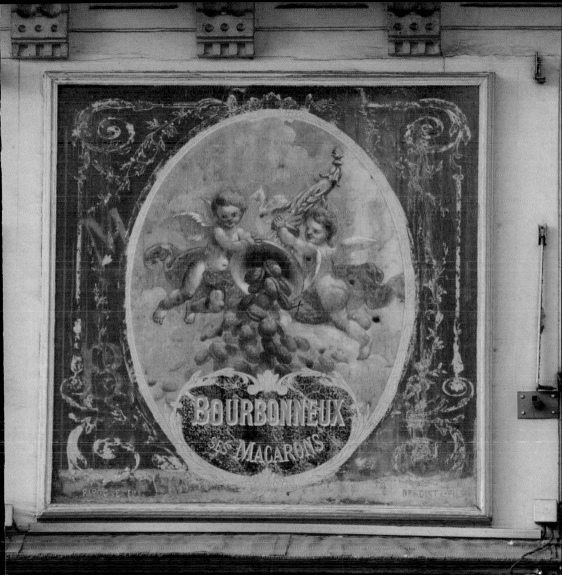

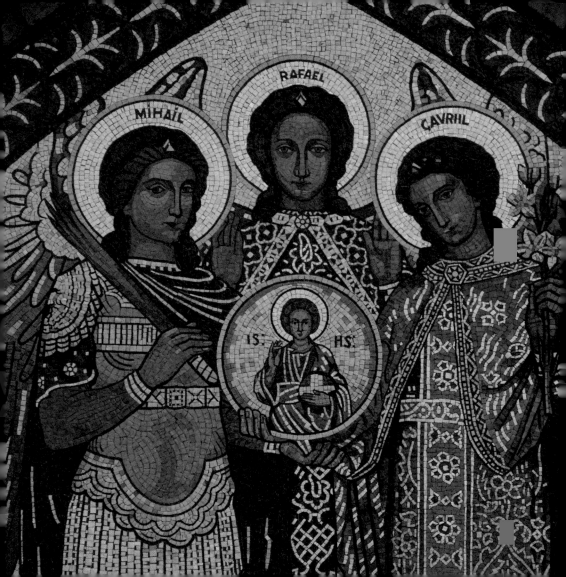

The Mosaic Angels
(1926)

✦

Church of the Holy Archangels
9, rue Jean de Beauvais, 5th arr.
Métro: Maubert-Mutualité

Mihail, Rafael, Gavriil: their names written in Romanian on golden haloes, Michael, Raphael, and Gabriel stand serenely on blue clouds above the entrance to the Romanian Orthodox Church of the Holy Archangels. Once the chapel of a medieval college, then transformed after the French Revolution into a uniform-making factory, barracks, and a warehouse, it was bought by the Crown of Romania in 1882 and placed under the protection of the archangels.

Portrayed in dazzling, colorful mosaic, the angels' figures are limned according to the canon of 6th-century Byzantine icons, with features strictly symmetrical. Their elongated noses and small mouths emphasize large almond-shaped eyes—the mirror of the soul—gazing straight ahead to establish contact with the spectator. It was believed that in rendering visible that which was not, the image would serve as witness to the existence of the divine cosmos. Because they know God, sacred persons had to be presented as impassive and calm; flattened, outlined poses suggested ethereal figures lacking in substance.

Mihail, the warrior angel cloaked in red, wears battle gear of breastplate, epaulettes, and open-toed boots; Rafael, patron

of travelers and doctors, is adorned in sumptuous gown and mantle, with hands open in prayer; and Gavriil, angel of the Annunciation, wears elaborate vestments of brocaded tunic, a star-studded gown and mantle, and holds a lily in his left hand. All are immobile, their marvelous pink and gold wings spread against a scintillating gold ground, symbolizing divine light in a place outside of space and time. Icons were meant to create contact with the person represented; it was believed that the saints projected their shadow or their energy on these images.

The art of the mosaic, developed by the Greeks around 400 BC, flourished in France from the 1850s onwards, instigated by architect Charles Garnier, who invited Italian mosaic artists to embellish the floors and ceilings of the Opera of Paris. They came with their tools and their *tesserae*—the tiny pieces of marble, stone, ceramic, and glass used to make mosaics. Soon mosaic workshops sprang up in the Parisian suburbs to meet the growing demand for the decoration of department stores, restaurants, public buildings, and churches.

Atelier Guilbert-Martin, renowned for their floor-to-ceiling work in the 1900 Grand Palais, would follow that commission with their masterpiece, the spectacular mosaic of the apse of Sacré Coeur, in 1923. At the behest of donor Elisabet Atanassio, in 1926 the firm would design the tympanum for this very small chapel, which would one day surely need the protection of angels. After World War II, the church, now the spiritual and political center for Romanian refugees and exiles, was almost taken over by the Communist regime and turned into a museum. Strong resistance on the part of its prelates—perhaps with a little help from the archangels—saved it.

Famous Romanian intellectuals, artists, and personalities such as the playwright Eugene Ionesco, the sculptor Constantin Brancusi, who was a cantor, and the actress Elvire Popesco have worshipped here.

The Angels of Mazarin and Minerva
(1674)

✦

The frieze which adorns the entrance to the Institut de France, one of Paris's most beautiful monuments, has all the artistic trappings in vogue during the 17th century—a mythological figure, angels, attributes of the arts and sciences. But the decoration, like the building's history, spans centuries and was carved by two different sculptors: one at the service of the monarchy, during the building's first incarnation as the College des Quatre-Nations, and the other under France's First Empire, when it became the Institut de France.

The College des Quatre-Nations originated with a legacy from Cardinal Mazarin, chief minister to Louis XIV, to found an academy to educate sixty young gentlemen originating from the recently annexed provinces of Artois, Flanders, the Alsace, and Roussillon. Building began immediately after his death in 1662 according to the designs of Louis Le Vau, the acclaimed architect of Versailles. The college is designed in a graceful hemicycle to accommodate student lodgings, classrooms, dining rooms, and the first library of France, which was filled with the treasures of Mazarin's own collection. The chapel in the center features a beautiful gilded dome, investing the building complex with an exceptional silhouette.

Etienne le Hongre, who had collaborated in Rome with Bernini, was admired for his statues in the Versailles

garden and his work on the Porte St. Martin in Paris. In 1674 he was chosen to sculpt decorations for the façade of the College chapel, including a marble portrait head of Mazarin, to be surrounded by the accoutrements of the arts and sciences, still there today: a palette, an iconic capital, a globe, a compass, and a lyre with musical partition. Le Hongre's *angelots* are buoyant, curly-haired cherubs in lively contrasting poses; drapery twirls about them as they carry laurel wreath and branch to honor their generous patron. They float against a background "glory," an ornamental foil popular in the 17th century. Le Hongre's frieze echoes influences of the Italian Baroque style, with its characteristic movement, variety, volume, and energy.

The College des Quatre-Nations opened in 1688 and thrived for more than one hundred years, until the French Revolution. During those tumultuous years, the bust of Mazarin was destroyed. In 1795, the College was transformed into the Institut de France, "the Parliament of the Learned." The building was to house five academies dedicated to research and the perfection of the arts and sciences: the French Academy (concerning language), and the Academies of the Humanities, Sciences, Fine Arts, and Moral and Political Science. The domed chapel became their meeting room.

In 1805 Napoleon Bonaparte called upon sculptor Jean-Antoine Houdon to chisel the head of Minerva, the Roman goddess of war and of wisdom, to fill the void where the image of Mazarin once reigned. Houdon created a staid visage, capped with a legionnaire's helmet, and wearing a breastplate in the spare, neoclassical style favored by the emperor.

Houdon was himself invited to *entrer sous la coupole* (enter under the dome), a term synonymous with becoming a member of the Institut, a supreme honor bestowed on the brightest stars of the French intellectual and artistic galaxy. Houdon had immortalized Voltaire, Molière, and Louis XVI in marble busts, an artistic pursuit which could have cost him his head during the Revolution, but he rode the wave of the changing political tides by being one of the first of the elite to renounce title and privileges in the Royal Academy.

Le Hongre's angels remain at their post, floating about gaily, now honoring the goddess who has become the symbol of the Institut de France.

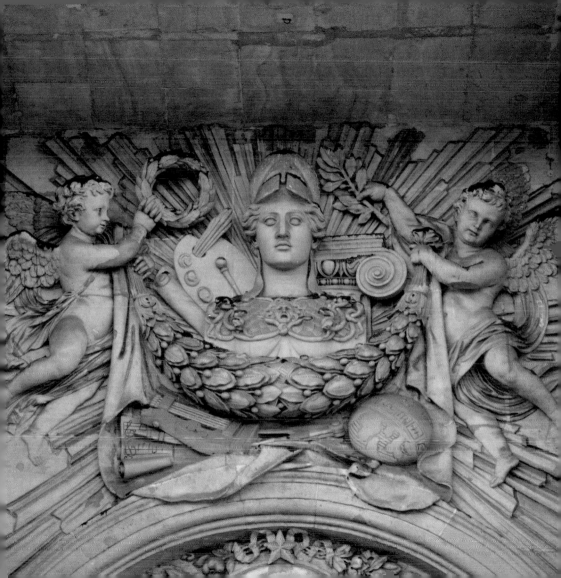

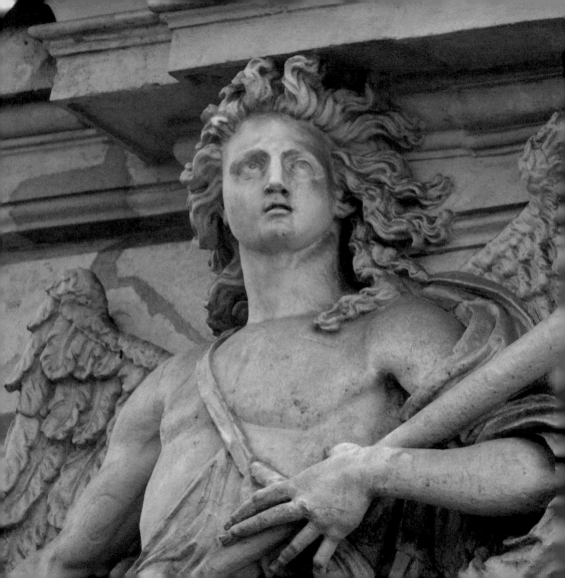

The Surgeons' Angels
(circa 1710)

✦

5, rue de l'École de Médicine, 6th arr.
Métro: Cluny-La Sorbonne, St. Michel

Ancient amphitheatres were open for the slaughter of man
Ours is created to prolong life
—Jean de Santeuil; inscribed over the amphitheatre portal

Magnificent long locks blowing in the wind, trumpets poised, two gorgeous winged figures swathed in diaphanous, flowing robes frame the entrance to the former school for surgery, built at the cusp of the 18th century. In French artistic language angels such as these, inspired by Roman divinities to symbolize renown and fame, are called *les renommées*. Adorning secular buildings, these angels often exuded a particularly human, and often sensual, allure.

Fame was indeed due to royal surgeons Charles-François Félix and Georges Maréchal, whose reputations grew following their successful operation on Louis XIV to remove a fistula. Reflected glory earned their confraternity of barbers and surgeons permission to build an anatomic amphitheatre in Paris between 1691 and 1695. Designed by Charles and Louis Joubert, it stands as testimony to the progress of scientific observation at the end of the 17th century. Master sculptor Jean-François Jacquin won the commission to design the carriage-door entrance.

Known as the Grand Jacquin and acclaimed for his flamboyant

decorative work on residences and churches, the sculptor fled his native Lorraine for Paris during the Thirty Years' War. His work at the school for surgery epitomizes the splendor of the *grand siècle*—the great century—under the Sun King. In dashing, elegant poses, the finely formed, muscular angels support with their fabulous feathery wings the curved pediment bearing the heraldry of France. Their faces, expressing a mixture of awe and naïve inquisitiveness, seem to capture the intellectual spirit of students attending lessons at the amphitheatre.

In 1775, the surgeons moved to larger quarters down the road, and the buildings became the site of a free royal school of drawing founded by Louis XV, dedicated to the study of draftsmanship and perspective. The stone oval panel held by the angel on the left is still engraved with the word Architecture.

Since 1969 the buildings have housed the Institute for Modern Languages of the Sorbonne.

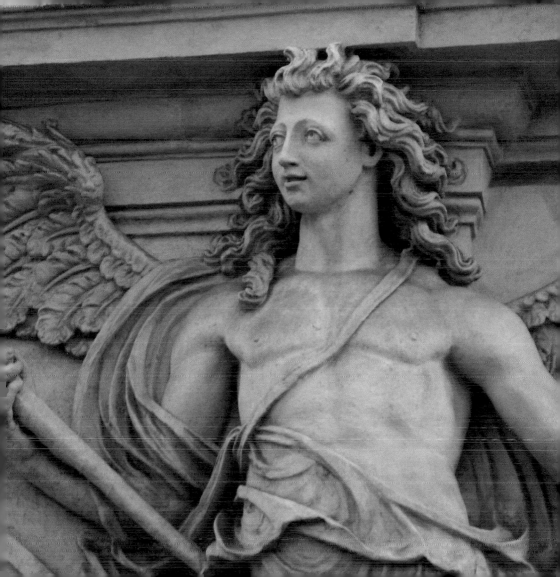

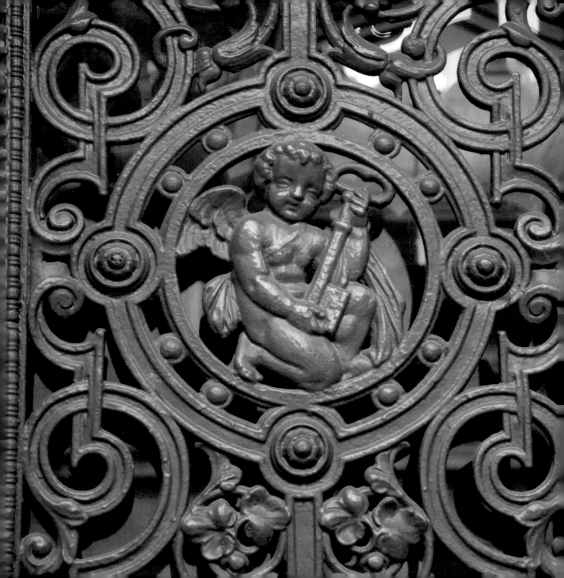

The Angels of the Latin Quarter
(circa 1830)

✦

40, rue St. André-des-Arts, 6th arr.
Métro: St. Michel, Odéon

On a medieval street winding through the Latin Quarter, two little angels huddle inside the medallions of a cast-iron door grill. One holds a gigantic key—the key to knowledge, perhaps?—and he has a little knapsack slung across his shoulder; maybe it is full of books. His companion angel mysteriously holds his finger up to his lips, the universal sign for silence, as he holds a very small volume up to the spectator.

Advances in cast-iron production occurred during the rise of the industrial age in the 1830s, and coincided with a period of reconstruction under Louis-Philippe. This decorative door grill would have been sold by catalogue; it can be found throughout Paris. Yet the angels' references to books and knowledge is particularly in harmony with the spirit of the Latin Quarter—parts of the 5th and 6th arrondissements centered around the Sorbonne, just down the road from the rue St. André-des-Arts, where, in the Middle Ages, international students spoke Latin as their lingua franca. Despite the passage of centuries, this area remains home to binders, sellers, and publishers of books.

The street took its name from the church built on the

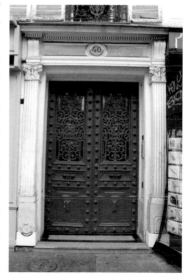

nearby square in 1212; it was closed after the Revolution and demolished in 1808. Later called the rue St. André-des-Arcs when merchants of archery equipment plied their trade here, the streets name changed to St. André-des-Arts after a theatre was established here in the 17th century; many of the mansions on the street date to that era.

The sturdy but whimsical angels' door grill is typical of mid-19th-century exuberance. The ornate door, punctuated by rows of cabochons and bead-like detailing, features fancy handles and a detailed lower panel. A touch of the Renaissance completes the picture with a doorframe of fluted stone pilasters topped with elaborate capitals.

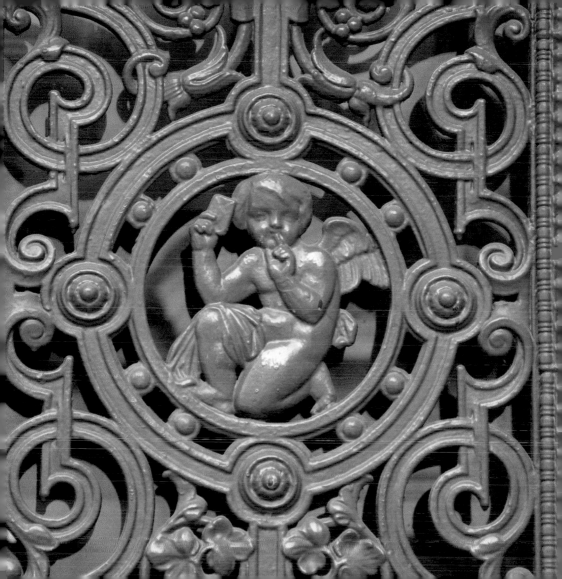

The Joyful Angels
(1847)

✦

17, rue Duguay Trouin, 6th arr.
Métro: St. Placide, Notre-Dame-des-Champs

A pair of beguiling cherubs delightedly skips off clouds, their wings slightly detached from the lintel, as they float in to bear a graceful oval medallion featuring the number of the address of this residential building.

Documents handwritten in sepia ink in the Archives de Paris reveal that the building site was acquired in 1847 by a certain Mr. Gautier, who hired an architect to construct a ground floor. The

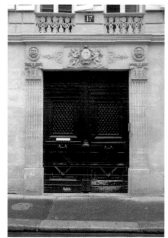

attractive doorway with its elegant Corinthian pilasters and joyful angels was created at that time in the fashionable Renaissance revival style. The angels carry the numeration as a welcoming coat of arms for the building.

Gautier was given permission to add on four additional floors a few years later. The difference in the color of the new stone is noticeable, but a fluted architrave and balustraded balcony join all together harmoniously.

The street was opened in 1790 on a part of the Luxembourg Gardens sold by the count of Provence, and named in 1807 after the dashing privateer René Duguay-Trouin, who became Lieutenant General of the Naval Armies of King Louis XIV. Ten ships of the French navy were named in his honor and a statue in his likeness reigns in the port city of Saint-Malo.

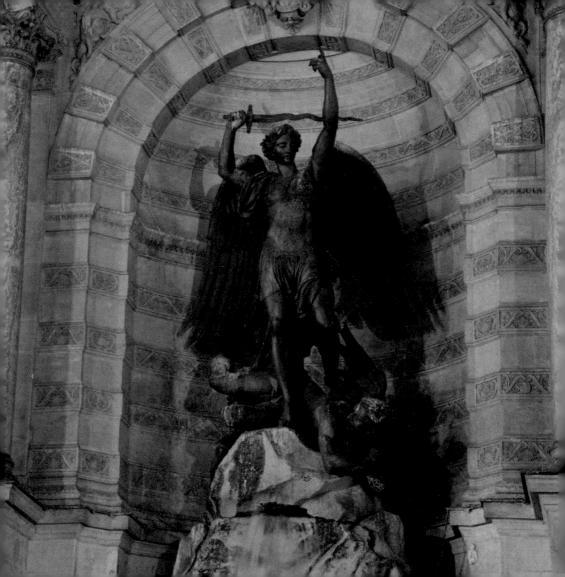

The Battling Angels
(1860)

✦

St. Michael Fountain
Place St. Michel, 6th arr.
Métro: St. Michel

There was war in heaven. Michael and his angels fought against the dragon, and the dragon
and his angels fought back... The great dragon was hurled down—that ancient serpent called the devil,
or Satan, who leads the whole world astray. He was hurled to the earth, and his angels with him.
—Revelations 12:3-9

In the heart of the Latin Quarter, atop the largest fountain in Paris, a mighty battle rages between good and evil. Michael, the warrior angel, brandishes his fiery sword and points to the heavens in a flourish of victory. A cowering Satan sprawls, twisting, his face grimacing in pain while Michael skips blithely over him, wings billowing, ready to fly off triumphantly.

Such is the drama that beguiles millions of tourists on their pilgrimage to the Latin Quarter. Of all the Parisian angels, St. Michael is unique in having a boulevard, a square, and a bridge all named in his honor. When it was decided to place a fountain at the site of the square carved out during the massive transformation of Paris in the 1850s, the first idea of Emperor Louis-Napoléon III was to adorn it with a statue of his uncle, Napoleon Bonaparte, but this was abandoned in favor of Michael and Satan.

Architect Gabriel Davioud designed a theatrical setting—a 26-meter-wide, 15-meter-high monument, with a large alcove for statues, four pink marble columns, and multi-tiered basins—to serve as an impressive point of perspective for the bridge in front and to mask the rump of buildings lining the freshly-plowed roads behind it.

Creation of the bronze protagonists was entrusted to the talented Francisque Duret. At the age of nineteen, he won the prestigious Prix de Rome, a generous stipend which allowed artists to study at the Villa Medici for several years and virtually guaranteed them the coveted state commissions for public art.

Duret portrays Michael with a Grecian profile, curly hair, dressed in Renaissance battle gear. An archangel, a high-ranking angel who acts as protector and leader, Michael appears in both books of the Bible and in the Koran. His Hebrew name means "who is like God," a rhetorical question the answer to which is "no one"; hence, Michael symbolizes humility before God. Perhaps this is why Duret gave him an impassive, detached expression in contrast to his heroic attitude. The angel's balletic pose was inspired by Raphael's painting of Michael and the dragon at the Louvre.

Satan, whose Hebrew name means "the opposer," is a handsome man with a powerful physique. In the book of Ezekiel, he is told: "You were the signet of perfection, full of wisdom and perfect in beauty," but he is ousted from heaven for denying that he is simply a reflected image of the Most High, instead claiming he had been engendered by his own powers and owed his beauty and glory to no one. Now the fallen angel, Satan has become bestial, wearing puny batwings, an allusion to the night and to his dark nature. Thrown onto the rocks beneath Michael, his face is alive with fury; a serpent coils around his body as Alfred Jacquemart's ferocious twin dragons gargle water into the base of the fountain.

Today the Fontaine St. Michel is the heartbeat of the Latin Quarter, and one of Paris's most popular meeting places.

Divine Birds
(1876)

✦

Chapelle des Auxiliatrices des Ames du Purgatoire
14, rue St. Jean-Baptiste de la Salle, 6th arr.
Métro: Vaneau

behold the angel of God: clasp thy hands... as the divine bird came towards us more and more,
he appeared brighter, so that my eyes could not bear him close and I cast them down.
—*La Divina Commedia*: Purgatorio, Canto II: 29-30; 37-39, by Dante Alighieri
(prose translation: John Sinclair)

Perched like immense proud birds on each corner of the colorful tiled dome of the chapel of the Auxiliaries of Souls in Purgatory, their song the music of trumpets, Joseph-Marie Caillé's bronze angels seem to signal the Day of Judgment.

Completed by architect Just Lisch in 1876, the Byzantine-style chapel serves the order founded in Paris twenty years earlier by Eugenie Smet in the spirit of St. Ignatius of Loyola, with the motto "pray, suffer, act for the souls of Purgatory."

The notion of purgatory, a transitional state of those who have died in a state of grace but whose sins must be purged before attaining paradise, harks back to a universal history of caring for and praying for the dead to facilitate

133

passage to the next life. Found in Judaic and Buddhist traditions, it was enshrined in Roman Catholic doctrine during the Second Council of Lyon in 1274. The Catholic Church teaches that the fate of those in purgatory can be alleviated by the benevolent action of the living.

Dante, the great medieval Italian poet, relates his imaginary journey with Virgil from the abyss of the Inferno, up the mountain of Purgatorio, to their arrival in blissful Paradisio in *The Divine Comedy*. In purgatory, a ship of souls is led by an angel, a "divine bird" too dazzling to behold.

Adorned in elaborate beaded Byzantine robes with wide drooping sleeves and hammered epaulettes, Caillé's divine birds are exotic angels with long, flowing capes. Their extraordinary hinged wings winnow the sky, forming a graceful arc with engraved oliphants—11th-century elephant tusk horns—held to their lips in a dramatic stance against the sky.

Today the congregation has shortened its name to the Soeurs Auxiliatrices, and expanded its social and ecclesiastical mission to include the earthbound in twenty-five countries. In France, the Auxiliaries help and protect isolated immigrant children.

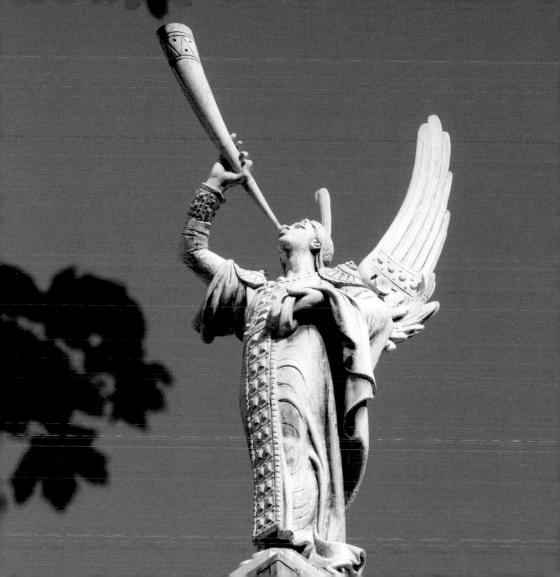

SCULPTURE
DECORATIVE

The Ornamentalist's Angel
(1881)

✦

4, rue Chartreux, 6th arr.
Métro: Notre-Dame-des-Champs

What a joy it must have been for Louis Villeminot to return home each day and see his own beautiful sculpture on the wall. Villeminot was one of the finest *ornamentalistes*, or decorative sculptors, of his era. Here, a young boy angel extols his trade while adding a touch of fantasy to the 19th-century building in which he lived.

The angel appears to have floated down from heaven, halting dreamily on the façade; a swath of drapery drifts gently as he gazes demurely towards earth. Adorned with a slender bandeau instead of a halo, the angel is laden with a carved Grecian-style woman's head and an Ionic capital —attributes of sculpture and of architecture—as he sways gracefully on long elegant wings. A budding laurel branch brushes against the wall, looking as if it has just been freshly cut from the tree. The title, *Sculpture Decorative*, is engraved below on the left.

Villeminot was active at worksites throughout Paris, including the Opera Garnier, the Louvre, and the National Assembly; he also carved decorative details on the Observatory fountain in the nearby Luxembourg Gardens and sculpted a pair of angels for the façade of the church of St. Germain l'Auxerrois. Passionate about the beauty and importance of the work of the influential sculptors and architects of his time, Villeminot collected hundreds of their drawings and renderings, identifying and dating them. Today, his treasures are found in many museum collections of 19th-century architecture.

Angels for the Duchess
(1736)

✦

Hôtel de Biron / Rodin Museum
79, rue de Varenne, 7th arr.
Métro: Varenne

Tucked under the slate roof of an elegant mansion on the Left Bank, a dreamy mythical drama unfolds on the pediment of the garden façade: Zephyr, god of the gentle West Wind, marries Flora, the goddess of flowers and spring, while cherubic angels sweeten the scene. The pretty goddess is in fact a duchess in disguise.

The hôtel de Biron, today the Rodin Museum, was home to the Duchesse du Maine, Louise-Bénédicte de Bourbon-Condé, a purebred aristocrat known for her cruel and clever wit. She had maintained a prestigious literary salon at her previous abode, the grandiose château de Sceaux just south of the city, and was friends with Voltaire, Rousseau, and the Marquise du Châtelet. Recently widowed and obliged to reduce expenses, the duchess moved to the more modest Parisian mansion in 1736, where she resided until her death in 1753. During her tenure, she renovated the interior wood paneling and added the fanciful low-relief sculpture to the pediment.

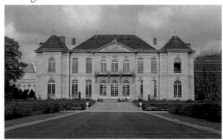

Lively and erudite, the Duchess of Maine had the amusing idea of having herself portrayed as Flora, reclining indolently in a décolleté gown as she is crowned with a veiled garland of flowers, a symbol of her wedding to the handsome adolescent Zephyr. A young child stretches across her lap as a

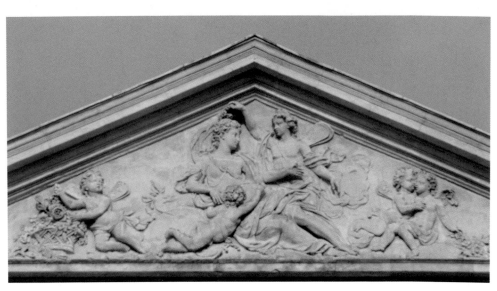

butterfly-winged cherub on the left reaches eagerly to offer flowers from his basket bursting with blooms. An affectionate pair of angels on the right echoes the romantic theme. One wears butterfly wings, meant to signify human form, and new life. The other, trailing a stream of flowers, bears beautiful small bird-like wings, typically associated with baby angels, so beloved in 18th-century art. In true Rococo style, the theatrical, light-hearted scene rolls with movement, swirling draperies, and floating clouds.

It was an exciting time to live in this area known as the faubourg St. Germain-des-Près, which was expanding rapidly due to its close proximity to the court of Versailles. Architect Jean Aubert, acclaimed for his work on the Chantilly stables and the Palais de Bourbon of Paris, finished the stately home in 1732 for a financier. The illustrious Marshal Biron, whose name it bears today, would later buy the mansion.

Angels of the Four Seasons
(1739-1745)

✦

Fontaine des Quatre Saisons
57-59, rue de Grenelle, 7th arr.
Métro: Rue du Bac

Marble teen angels embody the four seasons on this beautiful fountain, designed by Edmé Bouchardon. More monument than fountain, the massive structure was commissioned in 1739 under Louis XV to supply water to the burgeoning population of the faubourg St. Germain. Just south of St. Germain-des-Prés and home to some of Paris's most stunning mansions, the arrondissement is on the curved axis of the route to Versailles; the fountain had to be worthy of its surroundings.

Bouchardon's life-sized pubescent angels evoke the subtle grace of adolescence, their nudity coyly concealed with spring roses, summer branches, autumn vines, and a winter's cloak. Spring is nudged playfully by a ram, the zodiac symbol for Aries; a crab, symbol for Cancer, is at Summer's feet as he grabs a sheaf of wheat. Grapes wind around a tree trunk and tumble from Autumn's hands, as Winter steps lightly over a goat, the sign of Capricorn. On the low-reliefs below, cherubs act out the earthly work of the seasons. Set in the curved niches of an immense crescent façade, the angels flank the core, where Paris, a proud, long-necked young woman, sits at the prow of a ship while figures symbolizing the Seine and Marne rivers slouch at her side.

From its very inception, the fountain was deplored by Voltaire, who nonetheless hailed Bouchardon as "our Phidias," evoking the great sculptor of ancient Greece: "I have no doubt that Bouchardon will make of this fountain a fine piece of architecture; but what kind of fountain has only two faucets where the water porters will come to fill their buckets? This isn't the way fountains are built in Rome to beautify the city. It should be built on a public square, to be seen from everywhere."

The fountain's 20-meter façade equals the width of the Trevi Fountain—for which, curiously enough, Bouchardon had submitted a project while studying in Italy at the Académie de France— but the rue de Grenelle, once a wide, dirt road, was nothing to compare with the piazzas of Rome. The Fontaine des Quatre Saisons would eventually be equipped with four lion's head spigots from which, to this day, trickle narrow streams of water.

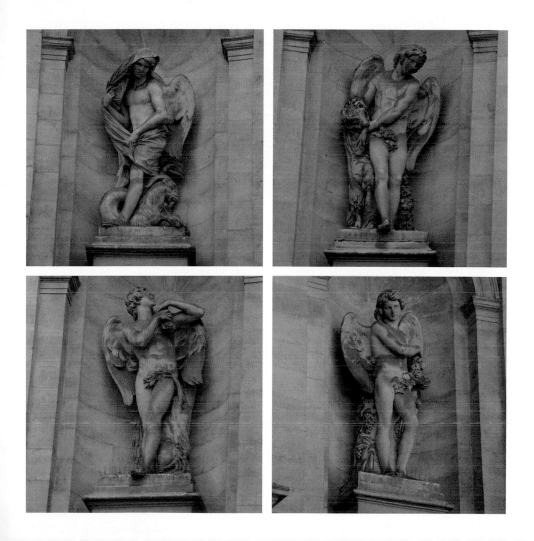

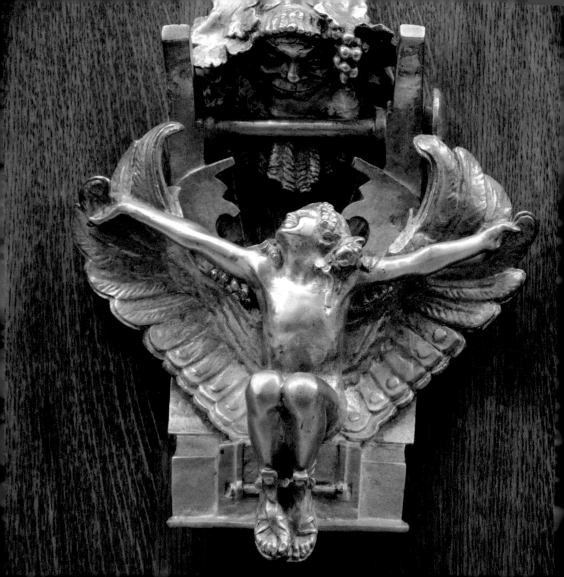

The Door Knocker Angel
(20th century)

✦

A smiling, long-haired angel with outstretched arms, furling the feathers of huge wings with his fingers, sits contentedly on this beautiful gilded bronze door knocker, gazing up at the grinning head of Bacchus, crowned with grapes and vines. The intriguing scene takes place on the oak entrance door of a fine 1914 townhouse by architect Pierre Leprince-Ringuet near the Seine.

Elegant and fanciful door knockers—*les heurtoirs de porte*, or door hammers—were widely used in Paris from the Middle Ages until the 20th century, when interphones, digicodes, and doorbells made them obsolete. This angelic door knocker has been called "Debussy's muse"—the composer was a constant visitor here, the home of his publisher, Auguste Massacrié-Durand.

Durand himself had studied the organ and played at Parisian churches in his youth, all the while writing as a music critic and composing. He made his fortune by acquiring and selling music catalogues and acquiring rights for the French editions of the work of Schumann and Wagner. The business continued under his son Jacques, who specialized in the publication of great French composers such as Saint-Saens, Ravel, and Massenet.

Above the door, Durand's monogram is cast in wrought iron; a frieze of dancing musicians graces the first floor façade.

The Composer's Angel
(1904)

◆

Square Samuel Rousseau, 7th arr.
Métro: Solférino

Joyous or melancholy, solemn or mystic, powerful or ethereal: Franck was all those at Sainte-Clotilde.
—Memoirs of Louis Vierne, composer and organist

Set in the leafy square in front of the Church of St. Clotilde, an attentive, maternal angel hovers over the pensive Romantic composer, César Franck, in Alfred Lenoir's 1904 stone monument. Head bowed, arms folded, seated at his beloved church organ, Franck seems stalled in the act of creation, oblivious to the angel's smiling presence. Attired in flowing robes, holding a long banner listing Franck's most famous compositions, she seems to have come to inspire him.

Franck's family arrived in Paris from Belgium in 1835, so that he could study at the Conservatoire. After winning several prizes, he enjoyed a career as a virtuoso pianist and was appointed primary organist at St. Clotilde in 1859, a post he would retain until his death. Here he wrote one of his most enduring compositions, the communion motet, *Panis Angelicus* (the bread of angels). In 1872 he was made organ professor at the Conservatoire, and devoted more time to composition. But his artistic evolution was slow: Franck wrote most of his masterpieces, such as *Le Chasseur Maudit* and *Les Béatitudes*, after the age of fifty. Known as a man of the utmost humility, simplicity, and industry, his work reflects a romantic lyricism fused with a genius for improvisation.

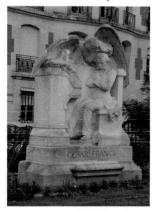

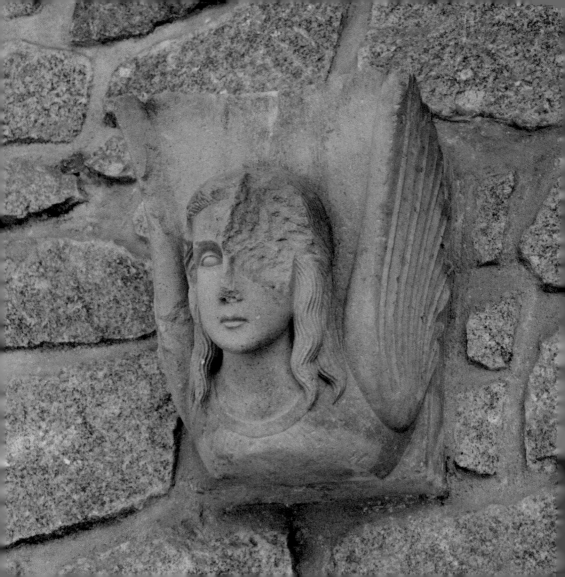

The Angel of Nagasaki
(1925)

✦

UNESCO Garden of Peace
7, place de Fontenoy, 7th arr.
Métro: Ségur, Cambronne

One enters into the Japanese garden of UNESCO as into a haven of peace. There flows an almost unearthly sense of tranquility and well-being, born of the Zen-inspired juxtaposition of its elements. Gently swaying branches of bamboo, cherry, and plum trees, soft-colored magnolia, lotus, and iris flowers have been unerringly arranged amongst rugged granite and volcanic rocks by artist and landscape architect Isamu Noguchi. Yet what awaits us on the wall at the far end of the garden, after crossing a delicately bowed bridge over a layered reflecting pond, is a moving vestige of the tragedy of war.

The head of a somber stone angel is one of the few sculptures of St. Mary's Cathedral to survive the atomic bomb dropped on Nagasaki on August 9, 1945. The cathedral, also known as the Urakami Church, was a brick Romanesque structure completed in 1925. It stood only 300 meters from the epicenter of the blast.

The angel's left eye and forehead were blown off by the explosion, yet her feminine, solemn demeanor remains, elegantly framed by hair and wings striated in Art Deco style. As a gift from the Japanese government in honor of the thirtieth anniversary of UNESCO, the angel became part of the Japanese garden, and endures as a poignant, silent plea for peace.

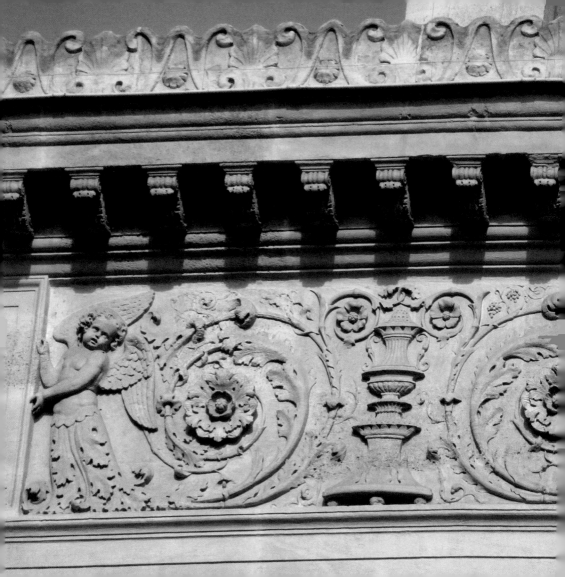

The Arabesque Angels
(1838-1839)

✦

Hôtel de Pourtalès
7, rue Tronchet, 8th arr.
Métro: Madeleine

Modern art is the product of the evolution of the past and in itself is neither complete nor final,
but merely a piece added in its own time.
—Felix Duban, architect and designer

Along the upper story of an elegant *hôtel particulier,* charming curly-haired angels with wings atilt gracefully hold small rectangular window frames. Their foliated mermaid-like bodies scroll into arabesque spirals, bringing a whimsical touch to the sober façade.

To create a luxurious residence to house his family and his personal art gallery, Count James-Alexandre de Pourtalès, a distinguished Swiss banker, diplomat, and art collector, chose Felix Duban, an architect known for his "curious and romantic character."

Duban, winner of the Grand Prix d'Architecture and, as a student at the Ecole des Beaux-Arts, the Prix de Rome, had spent 1824-1829 at the Villa Medici in Rome. During this time, some beautiful Etruscan tombs were discovered; Duban immersed himself in making drawings and watercolors of Etruscan vases, altars, urns, and columns in Tuscany, and of Renaissance monuments in Rome. These studies became part of his creative consciousness, manifesting in his later *fantasies*

architecturales such as the arabesque angels.

The arabesque, a decorative pattern of entwining plants and curvilinear motifs, derived from the work of Muslim artisans in the first millennium. For religious reasons, depictions of birds, beasts, and human figures were forbidden, and so artists' imaginations took flight with fantastical, exaggerated renderings of flora and fauna. Revived during the Italian Renaissance, arabesque motifs evolved to include flourishes of figures, such as angels and animals, to enliven the décor of the Vatican loggia, majolica designs, and Florentine tapestry. Duban's angels, their leafy arabesque tails coiling into floral designs, set beside antique urns, brought ancient and Renaissance motifs into the 19th century, in a new synthesis.

Duban is acclaimed for his Pompeian-inspired design of the Palais des Etudes courtyard at the Ecole des Beaux-Arts and for his restoration of the château de Blois in the Loire Valley. The hôtel de Pourtalès was made a historic landmark in 1927.

The Archangel Michael
(1840)

✦

Church of the Madeleine, southwest corner
Place de la Madeleine, 8th arr.
Métro: Madeleine

The rectangular niches of the peristyle of the Church of the Madeleine are filled with a series of statues of saints, with the exception of the corners. North, south, east, and west, an angel anchors each direction, as if to safeguard the church against future upheavals—the church has been marked by a tumultuous past. This particular parish of the 8th arrondissement was served since the Middle Ages by a chapel dedicated to St. Mary Magdalene located at the entrance to the present boulevard Malesherbes. The decision to erect a new, monumental church was made in 1757, as the result of a royal project to develop the west of Paris around a square in honor of Louis XV. This edifice was intended to form part of the perspective of the new square, the place Royale, today's place de la Concorde. Construction was entrusted to Contant d'Ivry; work began in 1764 and continued until the Revolution. By then the walls were up and the portico

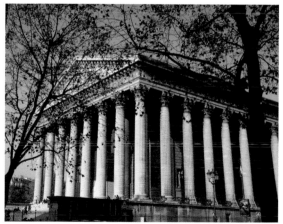

built. Half-finished, the project stalled for several years until Napoleon Bonaparte decided to turn it into a temple to the glory of the French armies. Architect Pierre Vignon razed the church but saved its columns to create a modern version of a Roman temple. Work was not completed until 1828; by then the emperor had fallen from power. The Restoration monarchy that followed reverted the building back to its original *raison d'être* as religious edifice. Its front pediment commissioned from Henri Lemaire in 1830 portrays a Last Judgment scene with Mary Magdalene interceding for the damned. The church was finally consecrated in 1842.

On the southwest corner of the Madeleine stands Michael, believed by many to be above all other angels. An archangel, or high-ranking angel, he is one of the three angels mentioned by name in the Scriptures, along with Raphael and Gabriel. In the Book of Daniel, he is called the "great prince who stands up for the children of Thy people," and, most dramatically, in the Apocalypse, John recounts how Michael expels the rebel angel Satan and all his followers from heaven.

Michael played an important role behind the scenes in France: based on the 8th-century legend of his apparition at Mont St. Michel, Michael is considered the patron of mariners. In the Middle Ages, he was revered by the orders of knights both in France and in England. During the One Hundred Years War, Joan of Arc, a young peasant girl, received "bold and brilliant" visions of him, urging her to free her country from English occupation. Today Michael is the patron of police officers, paratroopers, and the military.

Here at the church of the Madeleine, in a departure from Michael's typical depiction as triumphant warrior, sculptor Nicolas-Bernard Raggi portrays him gazing with an imploring expression toward heaven, hand over heart, as if in a state of grace. A certain gender ambiguity—suggested by the angel's long hair and high-waisted, tiered gown that billows over his feet—is dispelled by his broad jawline and thick neck. Engraved on the plinth is the honorific, "St Michel;" angels, however, are not canonized. Here the word saint implies holy. September 29 is Michael's feast day in the Christian calendar.

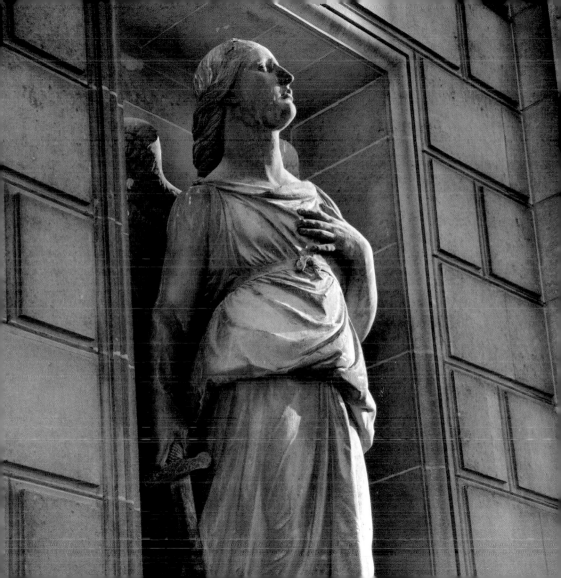

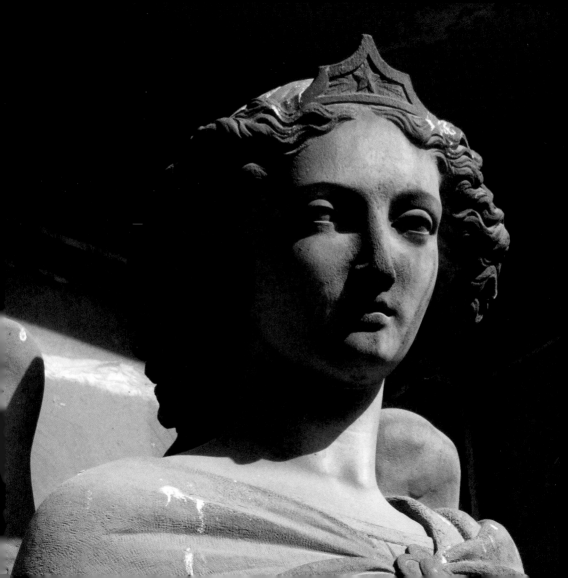

The Archangel Raphael
(1841)

✦

Church of the Madeleine, northeast corner
Place de la Madeleine, 8th arr.
Métro: Madeleine

Go with this man; and may God who dwells in heaven prosper your journey,
and may the angel of God keep you company.
—Tobit 5:16

Among archangels, Raphael is third in rank after Michael and Gabriel; his name means, "It is God who heals." Patron of apothecaries and of doctors, Raphael is also the protector of travelers, a role based in part on an account in a book of the Old Testament's apocrypha. In it, young Tobias is sent from Ninevah to a distant land by his aged and blind father, Tobit, to reclaim a debt. Raphael appears in human form, disguised as a guide for hire, familiar with the region. He names himself Azarias, assures Tobit of his experience, and his services are engaged.

Raphael will not only bring Tobias safely to his destination, but at the River Tiber orders him to capture an enormous fish, remove its gallbladder, heart, and liver, and conserve them for the voyage. The heart and liver are later burned to banish an evil demon plaguing Sarah, Tobias's future wife. Once Tobias returns home, the gall is applied to Tobit's eyes to remove a cataract. Only then does the angel reveal his true identity: "I am Raphael, one of the seven holy angels. All these days I appeared to you, yet I neither ate nor drank, but you saw a vision." He instructs Sarah and Tobit to record what has happened, and then disappears.

This endearing and colorful narrative fired the imagination of artists such as Leonardo da

Vinci and Verrocchio, who collaborated on a painting of Raphael and Tobit on their journey, and Rembrandt, who sketched, painted, or engraved virtually every scene in the story. Here, at the Church of the Madeleine, sculptor Antoine-Laurent Dantan presents Raphael equipped with a traveler's staff and a hooded pilgrim's cloak slung over his shoulders; the star-embossed tiara in his wavy hair is an unusual touch. At his feet lies a giant, toothy fish, now an emblem of the angel. Raphael's noble expression and pose, and the beautiful rendering of his garments, make Dantan's 1841 statue the most impressive archangel of the Madeleine.

The Archangel Gabriel
(1843)

✦

Church of the Madeleine, southeast corner
Place de la Madeleine, 8th arr.
Métro: Madeleine

Then the angel said unto her, "Fear not, Mary, for thou hast found favor with God.
And behold, thou shalt conceive in thy womb and bring forth a son,
and shalt call his name Jesus."
—Luke 1:30-32

The archangel Gabriel is the great communicator, entrusted to transmit the most important of messages. In the Hebrew Bible, he appears twice to Daniel, once to interpret the meaning of a vision, and then later to tell him of the coming of the Messiah. In the Book of Luke, Gabriel surprises Zacharias at the altar of a temple in Jerusalem, where he is burning incense, with the news that his aged wife Elizabeth will give birth to the future John the Baptist. The following verses relate that the angel has flown immediately to the young virgin Mary in Nazareth, to announce that she will bear the child Jesus. Small wonder, then, that an apostolic brief of 1951 declared Gabriel the patron of telecommunications.

Francisque-Joseph Duret interprets Gabriel for the Madeleine in the archangel's most familiar Christian role as the angel of the Annunciation. He is embodied as a somewhat androgynous being, wearing a long liturgical gown and holding a three-lobed lily, emblem of Mary's purity.

A leading sculptor of his time, Duret finished the statue in 1842; he was elected to the French Institute one year later. Soon after, he was appointed professor of sculpture at the Ecole des Beaux-Arts. One can almost hear Duret's precepts as he taught his eager protégés: "One must observe

with great care the lines and the overhangs... Look often at the profiles. Attend to the whole, check the overall planes; the details will come soon enough." Gabriel's head is tilted to the right with a shy, reserved expression, offset by the dynamic of the drapery's folds on the left against a backdrop of long, sweeping wings.

Duret won commissions for numerous Parisian churches, the Luxembourg Palace, and the Comédie Française. His most famous creation is the bronze duo of St. Michael the archangel and Satan for the fountain of the place St. Michel.

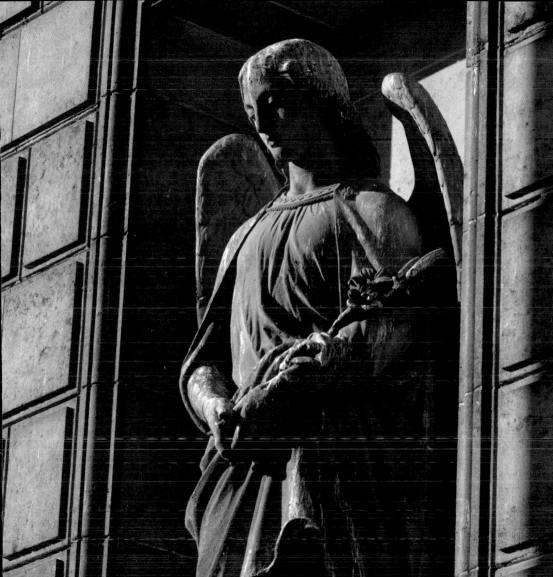

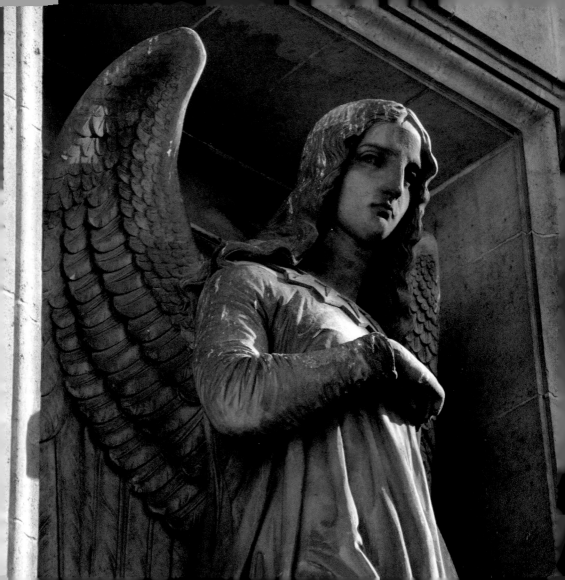

The Guardian Angel
(1842)

✦

Church of the Madeleine, northwest corner
Place de la Madeleine, 8th arr.
Métro: Madeleine

He shall give his angels charge over thee, to keep thee in thy ways.
—Psalms 90:11

Believers hold that each of us is assigned a guardian angel at birth to watch over us and to guide us. Some say their angel has appeared in a physical form during a time of dire urgency One such angel stands in the northwest corner niche of the Church of the Madeleine. Carved in stone by Theophile Bra, this guardian angel is decidedly feminine, with immense wings that could close around her like the shutters of a triptych. Most unusually, she holds a crosier in her left hand; in her right, drawn up to her breast, she once held a wooden cross, long gone. A somber expression of wary vigilance permeates her visage as she gazes obliquely to the right.

Known as an endearing and eccentric personality, Bra was independent of Parisian artistic circles. He fascinated Georges Sand and Honoré de Balzac, who admired him as a "sublime genius." Given to hallucinations and mystical experiences, Bra had strange visions of the world that he recorded in a diary he called the Red Gospel.

Devotion to angels began in the 4th century with St. Basil the Great, who maintained that each human being is accompanied in life by an angel acting as protector and shepherd. The tradition continued under the medieval reformer, Bernard of Clairvaux, who spoke with eloquence of guardian angels. In 1615, Pope Paul V honored the guardian angels by establishing their feast day on October 2.

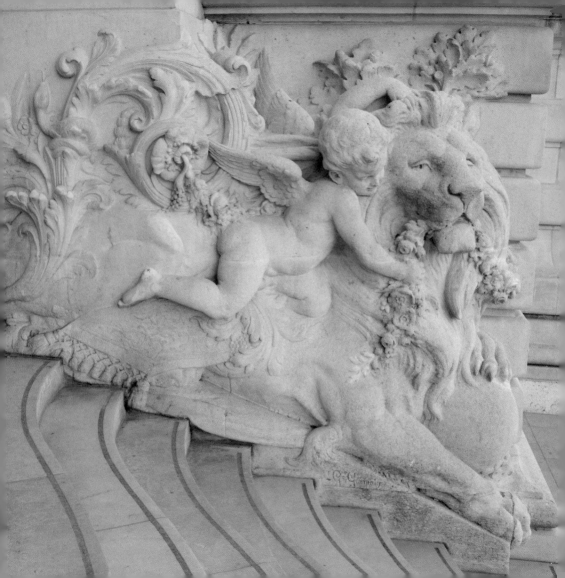

The Lion Tamer Angels
(1900)

✦

Palais de la Découverte
Avenue Franklin D. Roosevelt, 8th arr.
Métro: Franklin D. Roosevelt

Riding gaily astride enormous lions posed on the entrance staircase to the Palais de la Découverte—a science museum located in the Grand Palais—little boy angels bravely tame the beasts, stuffing flowers and garlands into their mighty mouths.

The ornamental sculptor Gustave Germain responded to the 1897 call to sculptors and artists for submissions to decorate the Grand Palais, destined to become a stunning showcase for the 1900 World's Fair. Noted for his work with figures and animals, Germain captures the lighthearted spirit of the millennium with one of the most charming and original animal sculptures in all of Paris. Lions—forever the iconic symbol of pharaohs, kings, evangelists, and emperors and a metaphor for majesty, strength, and power—here frolic in a romp down the staircase with celestial rascals. A cascade of flowers, vines, foliage, and vegetation trails in their wake.

Germain's design was chosen for the west wing, formerly called Palais d'Antin and designed by the

architect Albert-Félix-Théophile Thomas. The totality of the building was laid out in a strategic location on the new axis allowing quick access from the Invalides to the Champs-Elysées, thanks to the Alexander III Bridge, also built for the occasion.

The exterior and interior of this massive palace are replete with a voluptuous mélange of ironwork, ceramic, statuary, mosaic, and low-relief sculpture, in styles variously defined as Art Nouveau, Beaux-Arts, or Belle Epoque. Whatever they are, the building's components add up to jazzy riff on art in a dance to the new century.

The Palais de la Découverte, inaugurated in 1937, is now one of the world's finest science museums. It features permanent exhibits on physics, astronomy, mathematics, chemistry, geology, and biology. The entire building was classified as a historic monument in 2000.

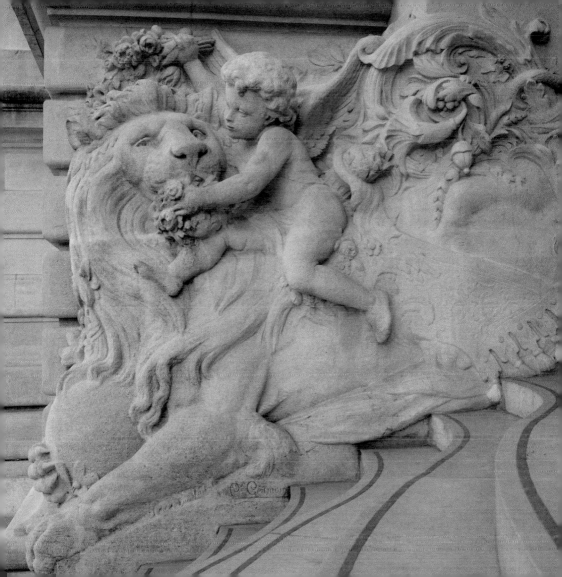

The Railroad Angels
(circa 1870)

◆

88, rue St. Lazare, 9th arr.
Métro: St. Lazare

Carved into a stone pediment on the façade of a former railroad headquarters, teams of angels and cherubs are busy on the tracks.

The PLM Railroad Company was a network of railway lines serving mainly southeastern France. The entry to their administrative offices, set up in 1870 on the rue St. Lazare near the train station, was designed with cast-iron grillwork doors set into an imposing stone portal with a clock in its pediment. Flanked by cherubs holding a steam pressure regulator and a wagon connection key, a frightful head of Medusa reigns at the summit. But it is the imaginative, delicate low-relief, sculpted above the curved side entrances, that captures the eye.

A cherub in the left team pours cornucopia—a presage of the abundance railroads will bring—onto the tracks, while another arranges it, all in front of a finely drawn steam engine. A third angel hauls a sack of coal over his shoulders. Into the scene a baby angel flies like a bird, waving a palm branch triumphantly, while yet another leans into the right corner; sadly, time has eroded the details.

The scene on the right transpires around a picturesque side view of the engine, billowing

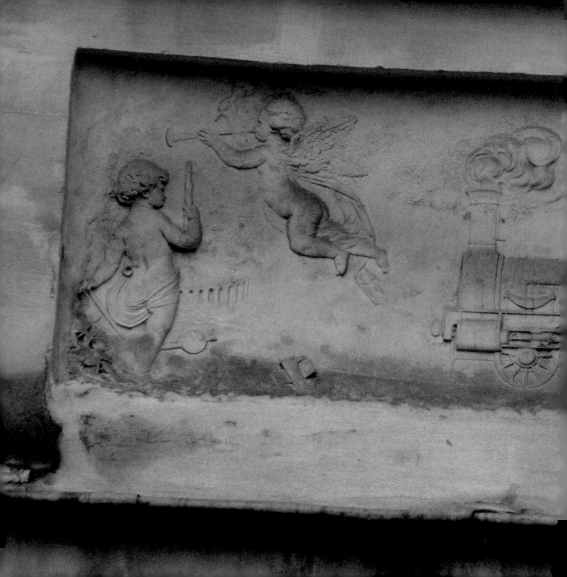

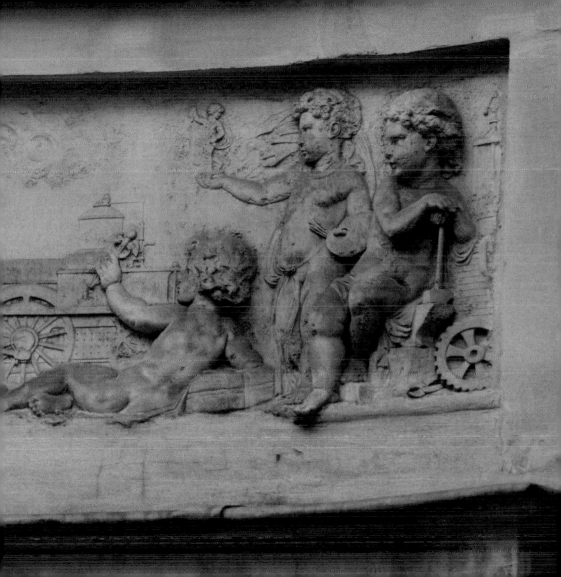

steam into the air like puffy clouds. A cherub standing on the left holds a points lever, used to align the points of a railway switch manually, and a torch for emergency signals. A gorgeous cherub on the right sits on his anvil, resting after driving railroad spikes with his sledgehammer. A gear rounds out the corner.

Allegory in art, which blossomed in Renaissance Italy, was still enthusiastically embraced in 19th-century France, even in railroad art. Here, a baby angel in flight toots his trumpet and carries a fiery torch, symbols of victory and of daybreak. A reclining cherub waves a caduceus, emblem of commerce—a reminder that the railroad is, above all, a commercial venture, destined to transport goods. Another child stands, holding a small figure in the palm of his hand in an allusion to sculpture, and carries a palette and brushes, tools of the art of painting.

Building permits were not required before 1880; unfortunately, credit cannot be given to the author of the décor, chiseled with such care and invention. The figures' charming poses, and the engaging three-dimensional effect achieved by setting fragments of the scene outside of its frame, recall the babes in 18th-century low-reliefs by the great French sculptor Clodion, surely a source of inspiration to the artist.

In 1938 the PLM was consolidated into the SNCF, France's national railroad company, which occupied this locale until 1999. Today it is the headquarters of an insurance company.

The Angel of the Opéra
(circa 1870)

◆

Palais Garnier
Place de la Opéra, 9th arr.
Métro: Opéra

Paris's magnificent opera house, today known as the Palais Garnier, was commissioned in 1861 by Napoléon III for the world-renowned Parisian opera and ballet companies. An avid lover of opera and theatre, the emperor wanted something grand, worthy of the prestige of the Second Empire. An international competition was launched, and of 171 candidates, Charles Garnier, a 35-year-old architect with no significant work to his credit, won unanimously. He would reveal himself to be a creative genius as well as an extraordinary master builder.

Construction began in 1862, with Garnier himself selecting the fourteen painters and seventy-three sculptors responsible for the décor of the interior and of the façade. Inspired by Renais-

sance palaces he had seen during his stay at the Villa Medici as a laureate of the Prix de Rome, Garnier had a taste for opulent architecture. He wanted the façades of his monument to offer a permanent spectacle to the passersby of Paris. Supervising every detail of the building, he chose stone from the quarries of Euville, reputed for its warm tones.

Jean-Baptiste Eugene Guillaume was

chosen to create an allegory of Instrumental Music for the main façade. Situated second from the left, the monumental group sculpture features Apollo, god of the arts, raising a scroll with one hand while balancing a lyre on his hip. Long-robed muses play medieval instruments: on the left, a shawm, the wind instrument of choice for outdoor performances, thanks to its piercing, trumpet-like loud sound, and on the right, a five-gut stringed fiddle, the French *vielle*, known for its dynamic range. But the trio lacks visual melody; it is a static, lifeless arrangement, well composed but dull.

Luckily Guillaume unleashes his inner child in the portrayal of a pudgy boy angel who arrives on the right side of the pedestal to save the show. Legs akimbo, hands on lap, he peers into the distance with a serious gaze, animated by thought. The gilded bird guard on his head glints in the

sun, looking curiously like a halo. A wingless cherub on the upper left turns toward him as a curved banner unites them in a rhythmic touch.

The opera house was inaugurated as the Académie Nationale de Musique in 1875. Garnier described its exhuberant, eclectic mix of elements from the Baroque, Classical, and Renaissance periods as the Napoléon III style. Napoléon III would be exiled, however, before it was completed, and due to official fury at cost overruns, Garnier would have to purchase his own ticket to a second-tier loge on opening night.

Today, the Palais Garnier is considered a masterpiece of its time, hailed as one of the most beautiful opera houses in the world. Since the construction in 1989 of the Opéra Bastille for large-scale productions, the Palais Garnier is a venue for small operas and dance performances. Its little stone angel lingers on the steps awaiting the audience.

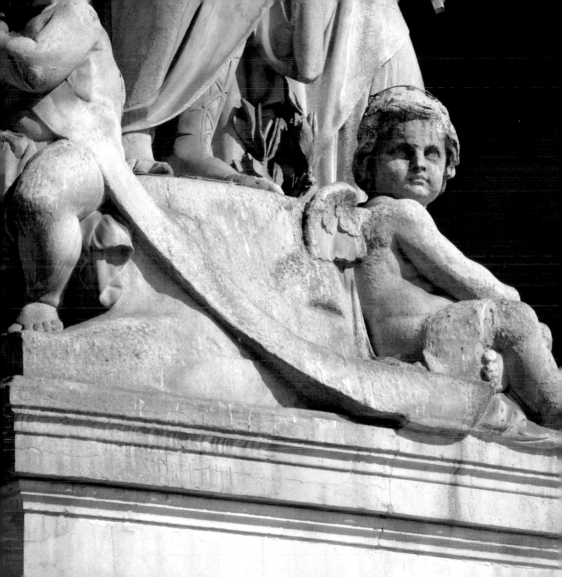

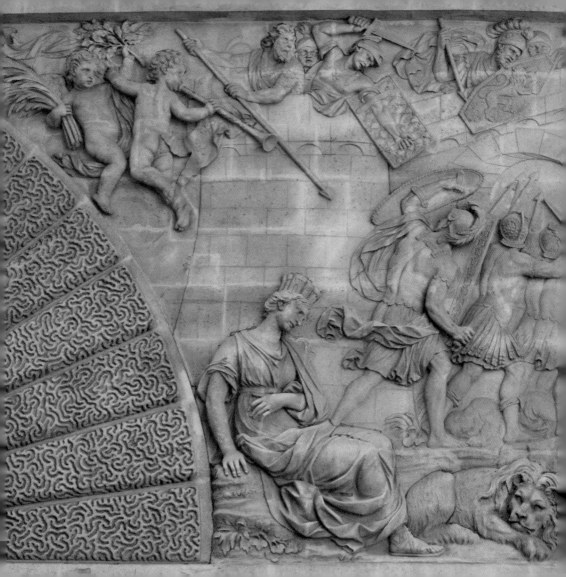

The Triumphant Angels
(1674)

✦

Porte St. Martin, rue du faubourg St. Martin side, 10th arr.
Métro: Strasbourg St. Denis

To Louis XIV for having twice taken Besançon and the Franche-Comté
during the wars with Holland and vanquished the German, Spanish and Dutch armies.
The Prevost of merchants and the magistrates of Paris.
—Inscription in Latin on the attic of the Porte St. Martin

Y ou can almost hear the sounds of trumpets resounding as angels and cherubs tumble about the arches of the regal Porte St. Martin, reveling in Louis XIV's victories during the wars with Holland.

The Porte St. Martin, erected in 1674, was the second in what was meant to be a series of five triumphal arches punctuating the new boundaries of Paris, tree-lined boulevards opened in 1670 at the former site of medieval ramparts. The remaining three planned arches were never realized owing to funds being diverted into building the Versailles palace and, of course, into yet more glorious battles.

Designed by Nicolas-François Blondel, military engineer, mathematician, and director of the Royal Academy of Architecture, the 18-meter high monument was constructed under architect Pierre Bullet to honor the 30-year-old Ludovico Magno, Louis the Great. Blondel conceived the *porte* or door—truly a

triumphal arch—with rigorous, harmonious proportions. He divided it in three equal segments: a great central arcade with two small lateral arcades, all devised in multiples of three or four to create a harmonious, balanced structure. An embossed vermicular (vermicelli-like) surface defines the structure's lines.

Etienne Le Hongre created the low-relief. On the left, toddler angels coast along the arch's edge near an allegorical treatment of the king as Mars, the god of war, fending off the German eagle and crushing the enemy at his feet. An angel waves a laurel wreath, the symbol of victory, and a lily, a reference to the emblem of the monarchy, the fleur-de-lis. Another cherub unrolls a finely chiseled drawing of a warship from a standard, as angels on the right jubilate. On the right side of the arc one sounds a trumpet against retreating armies, as a royal banner floats in the air; his partner brandishes an oak branch and sheaf of palms, codes for royal justice and for victory.

Today the Porte St. Martin is encircled by a platform to circumvent traffic, preserving this masterpiece of the official art of its era.

The Volcanic Rock Angels
(1862-1865)

✦

68, boulevard Magenta, 10th arr.
Métro: Gare de l'Est

Part of the story of Paris and its angels is that of the demolition and reconstruction of large areas of the city in the mid-19th century when the self-appointed emperor, Napoléon III, undertook the transformation of Paris into a modern metropolis. Baron Eugène Haussmann, an efficient administrator appointed Prefect of Paris, fulfilled the imperial orders with zeal, demolishing areas rich with architecture from centuries past.

The debris included the 17th-century portal of the church of St. Laurent, destroyed in order to extend the boulevard de Magenta from the faubourg St. Martin to the boulevard de Rochechouart, thus linking the Gare de l'Est with the Gare du Nord. Yet the modernization of Paris ironically kindled a nostalgia for its past. The truncated church now acquired a neo-Gothic façade and a tympanum evocative of Renaissance frescoes created by the process *émaillage sur lave*, enamel on volcanic rock.

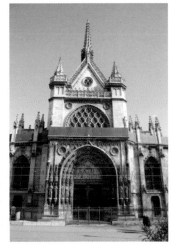

Developed in the early 19th century at the Manufacture de Sèvres, France's national ceramic and porcelain factory, the technique was initially used for making Paris's street signs; later it was employed for laboratory surfaces and by Michelin for road signage. Lava stone, which is produced in quarries from magma extracted and cut up in slices, is painted with viscous

enamel pigments and fired in kilns at temperatures of up to 1500 degrees Celsius. This creates an inalterable surface impervious to the elements and easily cleaned. Best of all, it can be rich in color, a property particularly exploited by Raymond and Paul Balze. Inspired by the work of Raphael, they used vivid pastel colors to illustrate the life of St. Laurent on the tympanum.

St. Laurent, born in Spain in the 3rd century, became a Roman archdeacon under Pope Sixtus II, charged with guarding the treasure of the Church and the distribution of alms to the poor. With the onset of the persecution of Christians under the emperor Valerian, Laurent was ordered to surrender the riches. He requested three days to do so, taking this time to distribute the wealth to the indigent. And then Laurent did indeed present Valerian with "the riches of the Church"—he brought in the old, the crippled, and the poor. The Prefect of Rome, furious, sentenced Laurent to death by being roasted alive on a gridiron. Because of his death by fire and his position as "keeper of the treasures of the Church," St. Laurent is the patron of fire and bankers.

The Balze brothers embellished their depiction of the story with the addition of two standing, blue-winged angels, dressed in yellow gowns. One wears a green mantle and holds a palm frond; the other, in a blue mantle, also holds a palm frond as he raises a laurel wreath. Both are symbols of the triumph of faith over death.

The Cabaret Angels
(circa 1909)

✦

10, rue de l'Echiquier, 10th arr.
Métro: Strasbourg St. Denis

The Concert Parisien, opened in the 1860s, was one of the most celebrated *café-concerts* of its time, where drinks were served along with an entertaining mix of songs, sketches, and circus acts.

These musical venues were still thriving in Paris during the Belle Epoque when, in 1895, a talented young singer named Felix Mayol made his debut at the Concert Parisien. Fame and fortune followed; Mayol bought the establishment in 1909. Renaming it the Concert Mayol, he sang in the shows he produced and welcomed young artists such as Maurice Chevalier. He also moved the establishment's entrance from the faubourg St. Denis around the corner to 10, rue de l'Echiquier, still close to the lively *grands boulevards*, in this area then famous for its theatres and cabarets.

Undoubtedly dating from that time, this duo of pearly-white stucco *amours*—decorative angels—was recruited to adorn the entrance. With wings perked up and long sashes trailing, they cheerfully festoon the oval window with long laurel garlands. The original colors have changed:

the crisscrossed diamond-patterned background was once red with green rosettes, and the angels and their garlands, gilded, creating a flashy façade to draw in the international clientele arriving at the nearby railway stations, the Gare de l'Est (then the Gare du Strasbourg) and the Gare du Nord.

The *café-concerts* were springboards for a new popular culture that expanded the rich tradition of French songs; Toulouse-Lautrec immortalized their stars in posters and paintings. By 1914, however, new directors appropriated the *café-concerts* and filled their stages with big variety shows. Later, in the thirties, scantily clad dancing girls were all the rage. After World War II, in a desperate attempt to survive, the Concert Mayol gave way to racy shows, and the cabaret finally closed its doors in 1976. Although the premises were transformed into a supermarket, a school of robotics, and finally a Chinese cultural center, the angels continue to happily hover about.

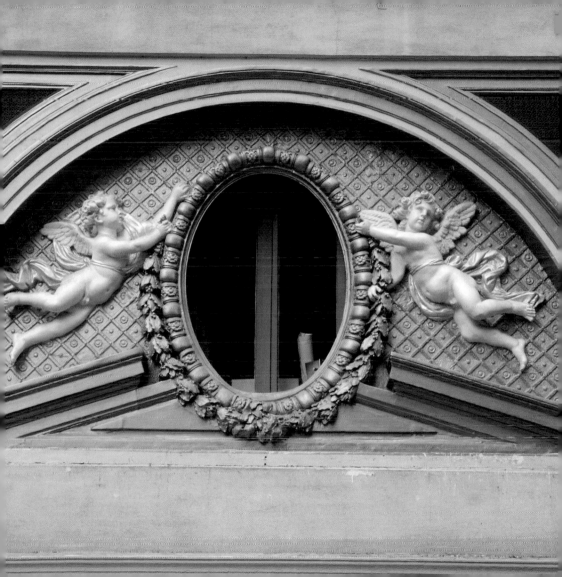

The Amours of the boulevard Voltaire
(circa 1865)

✦

202, boulevard Voltaire, 11th arr.
Métro: Rue des Boulets

Paradise on earth is where I am.
—Voltaire, 1694-1778

T he French call angels depicted in civic architecture *putti* if they are chubby babies, *génies* if grown adults personifying the arts, sciences, or abstract ideas, and *les amours* (the loves) for almost anything in between. Two charming *amours* hold architects' tools on this handsome residential building set on a broad, tree-lined boulevard that courses from the place de la Republique in the 11th arrondissement to the place de la Nation in the 12th.

The route has a history that reflects the politics of the time. It was constructed in 1857, under the enlargement and renovation of Paris commandeered by Emperor Napoléon III and his prefect, Baron Haussmann. In 1862 the emperor inaugurated it as boulevard Prince-Eugène, to commemorate his uncle, a brilliant military strategist. A statue of the prince was placed in the center of the boulevard, but it was not to everyone's taste. By 1864, an opposing faction of masons, freethinkers, and intellectuals petitioned to install another statue on the boulevard, a bronze effigy of François-Marie Arouet, the great 18th-century historian, philosopher, writer, and wit better known by his dashing *nom de plume*, Voltaire. Several newspapers launched a campaign, the Denier à Voltaire ("a coin for Voltaire"), to pay for the construction. The statue was cast but political polemics stalled its installation.

Voltaire's support of social reforms and religious tolerance—he defended and gave refuge to victims of religious fanaticism—as well as his satirical lampooning of aristocrats, landed him

in the Bastille prison on several occasions and led to spells of exile in England, Germany, and Switzerland. Voltaire's final home in France was near the Swiss border for easy transit in case of trouble. A century later, Voltaire's ideas were still making waves. The boulevard was renamed in his honor only after Napoléon III fell from power in 1870; his statue took pride of place there until its destruction in 1942.

Dust has settled on the political dramas, and the angelic *amours*, recently restored, blithely inhabit their own little paradise in graceful cameos embellished with sprays of flowers, a delicate presence between the first-story windows. The winged boy on the left stands with legs crossed in a rakish pose, leaning on a *té*, the long T-shaped architect's ruler, as drapery swirls around him. His girlish partner on the right sweetly holds an *équerre*—a T-square—high, near her shoulder; she poses demurely entwined by a ribbon of drapery.

Voltaire died in Paris in 1778. Refused burial there, he was interred in an abbey near Tours. The first ceremonial act of the Revolution was to move his ashes to the Pantheon, France's temple dedicated to the great men and women of the nation.

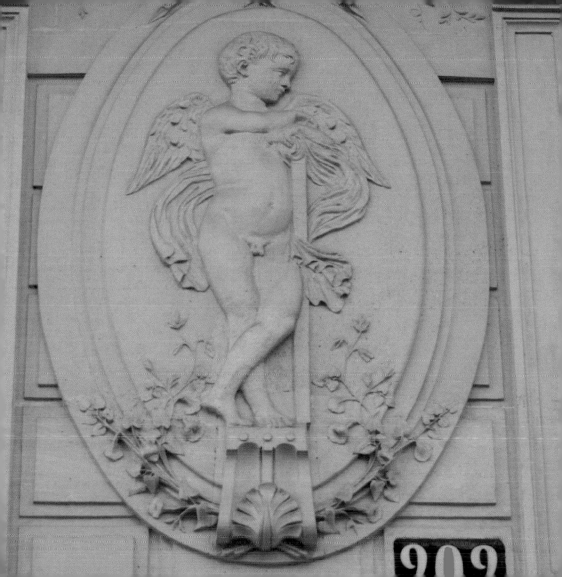

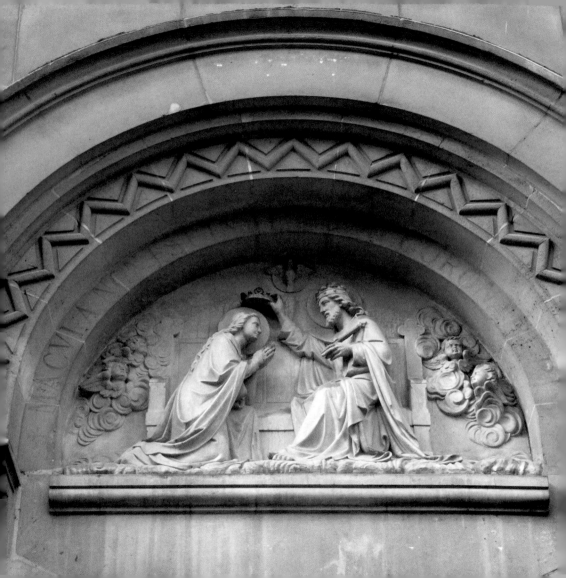

Angels in the Clouds
(1865)

✦

Church of the Immaculate Conception
34, rue du Rendez-Vous, 12th arr.
Métro: Picpus, Nation

As the population of the 12th arrondissement grew, it was decided in 1874 to create a new parish in the Picpus-Bel Air neighborhood. Abbot Olmer, at the time chaplain of the blind in a town just outside Paris, was named administrator. Construction began on a church to be dedicated to St. Radegund. The former chapel at this site was dedicated to this 6th-century Thuringian princess who became a queen to King Chlotar, and later, a nun.

One day the abbot met Sister Catherine Labouré in the house of the Daughters of the Sisters of Charity of St. Vincent de Paul, on the nearby rue de Reuilly. Known for her visions, she greeted him as "Monsieur le Curé"—the parish priest—and announced that he would call his parish "the Immaculate Conception, because there is not yet a church by this name in Paris."

And so on December 8, 1874, the parish took that name. The tympanum illustrates Mary being crowned by Jesus with the Holy Spirit, represented by a dove above them. Two pairs of angels, their heads collared with wings, swirl about on either side in spiraling clouds.

The church was constructed in 1875 by architect Edouard Delebarre de Bay and consecrated the same year on September 29, the feast of the angels, in honor of Michael, Gabriel, and Raphael. Abbot Olmer took up his duties as curé in 1877.

Catherine Labouré, who began the cult dedicated to the Immaculate Conception of Mary, died in 1876; she was canonized in 1947.

The Angels of the Wine-tax Church
(1859)

✦

Church of Notre-Dame de la Gare
Place Jeanne d'Arc, 13th arr.
Métro: Nationale

A feast is made for laughter, and wine maketh merry; but money answereth all things.
—Ecclesiastes 10:19

Block-like and ravaged by time, the giant, somewhat grotesque angels flanking the portal of the Church of Notre-Dame de la Gare strangely evoke a mute grandeur. Crowned with stone haloes, each holding a book and a huge laurel branch, they are part of the unique history of the 13th arrondissement.

The church was built on a gentle slope in what had been for centuries a village of vineyards and fields. It owes its name to that of the area, where an immense *gare batelier* (boat station) was to be dug into the nearby Ivry plain at the direction of Louis XV. The ambitious project never materialized, but the name endured. In the 1840s the district evolved into an important industrial area, due to vast terrain suitable for building factories and warehouses and proximity to the river and train lines. Sugar refineries, glassworks, and automobile manufacturers set up shop there, along with railroad workshops, metalworks, and manufacturers of lead oxide. The population grew, and a new parish was created by a charismatic priest, Louis...but there was no church.

However, there were many *guinguettes*, drinking establishments and restaurants with music and dancing, on the nearby banks of the Seine, where Parisians came in droves on Sundays. The area was outside the city limits until its 1860 annexation to Paris, and liquor was tax-free.

Father Parguel had the ingenious idea of setting up a temporary chapel in the *guinguette* La Belle Moissonneuse. He persuaded the Ivry municipal council to levy a special tax in 1852 to finance part of the construction costs for a new church, and then convinced *guinguette* owners to hike up the price of wine and turn the extra earnings over to the parish. With these funds and a few generous donations Parguel was able to hire architect Claude Naissant just three years later, and building began.

Inspired by late 12th-century Romanesque architecture, Naissant designed a massive, sober façade with small windows and decorative arcading around a semicircular portal. On the day of its consecration in 1859, a mischievous caricaturist drew the church with a bottle of wine at its summit.

The angels—monumental half-length figures on ornately decorated pedestals—seem to emerge from the walls in an inventive but jarring departure from the church's style. Adorned in gowns with beaded collars and epaulettes, they are surrounded by mystery. No documentation exists to attribute the sculptor. Decades of pollution from coal-burning factories have gravely eroded the stone.

Father Parguel rests forever in his beloved church; his tomb is inside on the right, in the Chapel de la Pietà.

The Armed Peace Angel
(1887)

✦

Parc Montsouris
Entrance rue Nansouty and avenue Reille, 14th arr.
Métro: Alésia; RER: Cité Universitaire

So he drove out the man; and he placed at the east of the garden of Eden cherubim,
and a flaming sword which turned every way, to keep the way of the tree of life.
—Genesis 3:24

Cherubim stationed to the east of Eden are the first warrior angels to make an appearance in the Bible, to guard its entrance after the expulsion of Adam and Eve. And so it is that at the northwest entrance to a lovely 19th-century Parisian garden—not quite paradise, but a bit of heaven in the city nonetheless—Jules-Felix Coutan's Armed Peace angel watches over the Parc Montsouris.

The majestic sculpture, its colossal wings opened wide protectively, is a decidedly feminine figure posing with an elegant swagger. Capped by a fetching helmet with upturned brim, devoid of armor or breastplate, she is swathed in a draped gown open thigh-high on the left, her right hand posed jauntily on her hip. A body-length sword is unsheathed in abeyance, more a warning than a threat, as a banner twirls rhythmically around it, sway-

ing in the wind as if to the music of a battle hymn. The curious pile of fruit at her feet reveals Coutan's sly humor: in the military, pomegranate and pineapple are slang words for grenade.

Armed Peace alighted Paul Sedille's beautiful Corinthian column in 1887. It was a time of monument building under the Third Republic, now into its second decade but still smarting from the destruction wrought by the Communards in their fury over French capitulation during the 1871 Franco-Prussian War. The government covered the city with landmarks dedicated to celebrating the new Republic. The statuary conveyed the government's wary truce with their own people in a symbolic assertion of control over public spaces and the urban consciousness.

The Armed Peace angel is a softer, gentler evocation of the contemporary political mindset, a mixed-message allegory of military readiness fused with a desire for harmony. Coutan's creation is at the same time a bronze guardian angel for the Parc Montsouris.

The talents of Coutan, a master of public statuary, were recognized abroad: Grand Central Terminal flaunts his masterpiece, *The Glory of Commerce*, the world's largest sculpture group of its time, installed over the 42nd Street entrance in 1914.

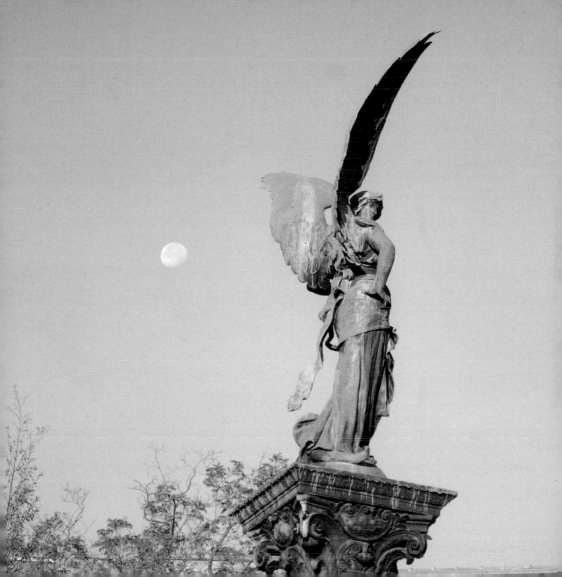

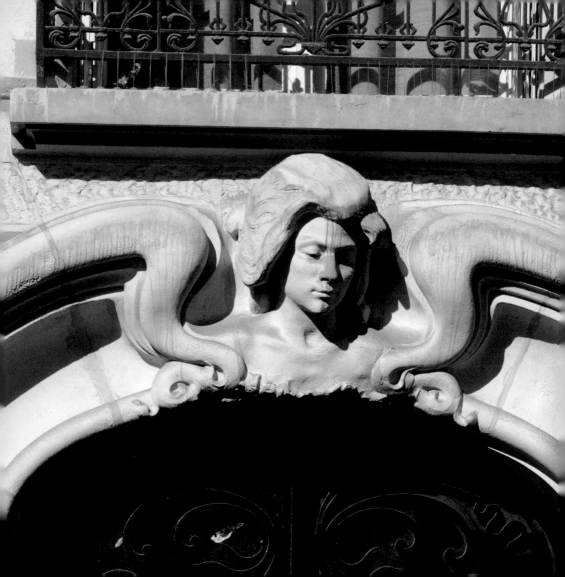

An Angel in Mourning
(1901)

✦

14, place Adolphe-Cherioux, 15th arr.
Métro: Vaugirard

Bordering a leafy square near the Town Hall of the 15th arrondissement stand rows of fine stone houses dating from the turn of the 20th century. One of them, designed by architect Henri Ragache, bears a beautiful but sad angel carved in the Art Nouveau style of the times, with long willowy wings swooping protectively around the doorway.

The house was commissioned in 1901 by a recently bereaved widow, Madame Fontaine, and it would appear that Ragache, in sympathy with her loss, imbued the angel with a pensive, melancholic expression, yet with the hint of a benevolent smile.

Flowing downward to frame the entrance, the angel's wings spiral into a cascade of sunflowers and vegetation at the base. The black wrought-iron door grill is also designed in *art nouille* ("noodle art"), the nickname given to the Art Nouveau style, with its characteristic curvy, undulating contours inspired by flora and fauna.

Ragache was a prolific Parisian architect whose work was considered to be of unequaled quality. This building is one of his gems, where the unexpected appearance of an angel is executed in a modern yet discreet style that conforms with the bourgeois character of the neighborhood.

The place Adolphe-Cherioux, originally Vaugirard Square, was renamed in 1935 to honor a municipal counselor.

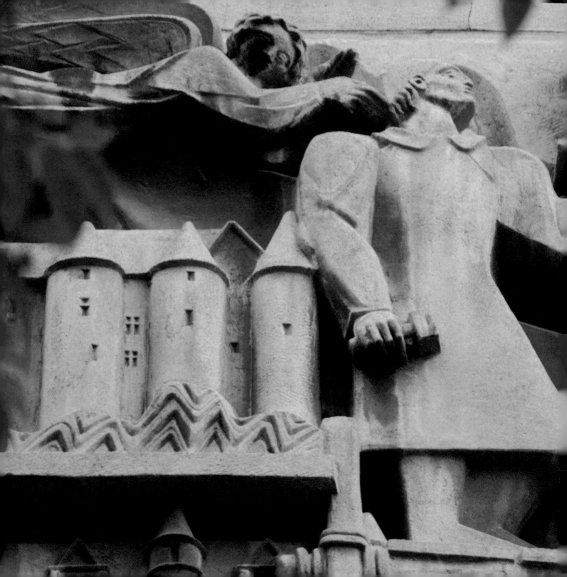

The Angel of Architecture
(1937)

✦

Palais de Chaillot, avenue President Wilson façade, 16th arr.
Métro: Trocadéro

Within these walls dedicated to wonders
Host and preserve the work
Of the prodigious hand of the artist
Equal and rival of his thought
One is nothing without the other.
—Inscription above the entrance to the Palais de Chaillot

G liding in from the left to lend a hand with a chisel, Jean-René Debarre's angel is an enigmatic addition to his fantastical low-relief pastiche of Civil Architecture created for the façade of the Palais de Chaillot. Fourteen tableaux dedicated to the arts, the continents, and the sea, each designed by a different sculptor, embellish the 195-meter curved wings of the monument that was finished in time for the 1937 World's Fair. Only Debarre's has an angel.

Round-headed, streamlined, with harlequin-patterned wings and a smile, the angel paddles through the air above a moated fortress to put the finishing touches on the figure of a sculptor who is portrayed sideways, standing on scaffolding as he chisels away at an Egyptian-style capital. An elegant Parisian building, houses, factories, a silo, and even a construction crane surround the heroic architect, cape thrown across his shoulders as he clasps blueprints and a compass in one hand and a ruler in the other. A tree branch sprouts up behind him; two toy workmen march along shouldering a beam on the right.

Created in *simili pierre*—a cost-saving mortar composed of quicklime, cement, and powdered

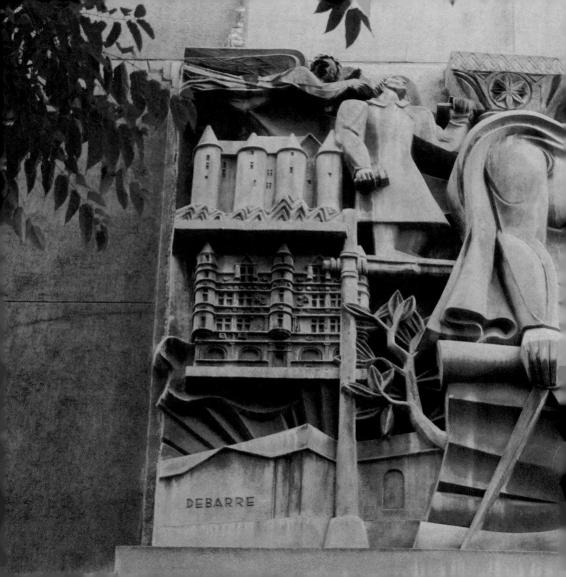

DEBARRE

limestone used in that time of economic crisis—the panel has aged badly. Yet Debarre's witty and humorous spirit endures, in a chunky, rounded style assimilating the waning Cubist and Art Deco movements; it would come to be known simply as *entre deux guerres*—the "between the two wars" style.

A monument—an unpopular building in exotic Moorish style—was first built at this site for the 1878 World's Fair. The 1937 World's Fair was the catalyst for its "organic transformation" as conceived by the architects Boileau, Carlu, and Azema; the original brick structure was enlarged and camouflaged with a new colossal façade of reinforced concrete. In addition, the theatre originally anchoring the center of the building was razed, opening up a 55-meter terrace offering a spectacular view of the Eiffel Tower across the Seine.

Today's Palais de Chaillot houses the naval museum, a center for architecture and patrimony, a theatre, and the museum of national monuments.

The Golden Archangel
(1894, 1934)

✦

Church of St. Michel des Batignolles
12 bis, rue St. Jean, 17th arr.
Métro: La Fourche

Swaggering atop the pinnacle of St. Michel des Batignolles Church, St. Michael brandishes his sword triumphantly, while crushing the dastardly dragon at his feet. Michael is an archangel, a high-ranking angel seen as leader of the celestial army against the forces of evil; he appears in the Old and New Testaments of the Bible, as well as in the Qur'an. The six-meter, gilded statue is an exact replica of Emmanuel Fremiet's sculpture of St. Michael created originally for the abbey church of Mont St. Michel in 1894.

Yet it was almost not to be. Fremiet, acknowledged as one of the greatest sculptors of his time, his talents recognized with numerous awards and medals, suffered a *crise de decouragement*—a depression—after the 1871 Franco-Prussian War. He questioned his profession, which he began to feel was a frivolous pursuit, and considered abandoning it altogether to go and live in the provinces. For a long time he neither drew nor modeled. But the dark days passed, followed by a renewed enthusiasm manifested in some of his most important works.

Fremiet, a perfectionist with a passion for historical realism, chose the medieval knight as his prototype for Michael. His quest for authenticity shines in precise details: the chainmail headgear,

articulated armor, and pointy shoes; a spiky sunburst halo caps a studded helmet. The comical discrepancy between heroic Michael's monumental stature and the puny, coiled demon clawing at his feet betrays the sculptor's wry sense of humor.

Construction of the church began in 1913, adjourned during the war, and resumed in 1925, when oxen-drawn carts hauled six tons of monolithic granite columns from the banks of the Seine up to the worksite, where they were used to support the central nave.

The archangel, however, was relatively lightweight, thanks to Fremiet's technique of using hammered copper plates instead of molded bronze; these were mounted on an armature, assembled with rivets, and then gilded. The church was finally completed in 1934, when St. Michael was hoisted to its summit, his luxurious cladding a droll contrast to his 37-meter perch, built of homey red, pink, and yellow brick.

Fremiet's masterpiece received a glowing review from the magazine *Construction Moderne* the same year: "The proud bell tower has just been crowned with its statue, whose new gold gleams richly in the sun for the greatest joy of a popular district, until now little favored by art and beauty. The gilded chevalier, with powerful and vigorous arms, and grand, majestic wings, dominates the neighborhood and attracts the looks of all the passersby."

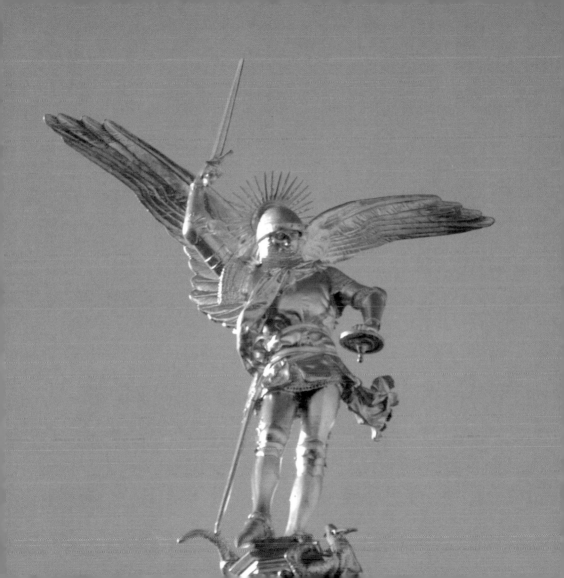

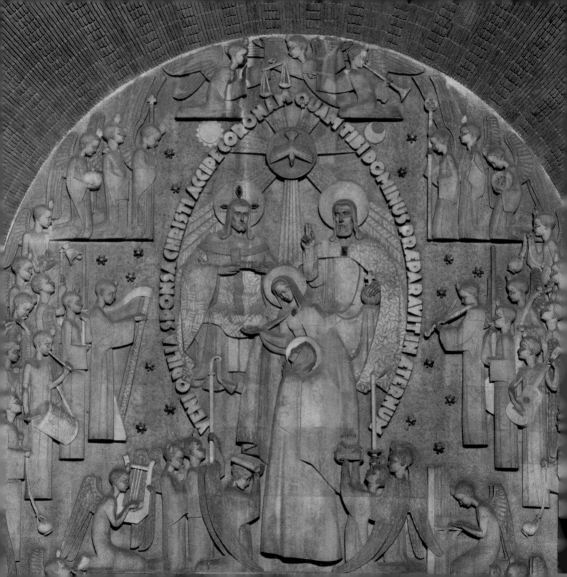

An Orchestra of Angels
(1935)

✦

Church of St. Odile
2, avenue Stéphane Mallarmé, 17th arr.
Métro: Porte de Champerret

J ust off the autoroute encircling Paris stands an immense modern church with a rose ocher façade of startling and original beauty, alive with Anne-Marie Roux-Colas's orchestra of angels, playing to honor St. Odile, the patron saint of Alsace-Lorraine.

Odile was born blind circa 632 in Obernai, Alsace, to an aristocratic family. Rejected by her father, Duke Adalric, Odile was sent to Burgundy to be raised. There she miraculously recovered her sight upon being baptized at the age of twelve. She was brought back to Alsace, where Adalric tried to force her to marry a young prince, but Odile had consecrated her life to God. She refused, and fled to a cave. Adalric eventually relented and offered her a castle, where she founded a monastery and became its abbess.

The captivating façade of the church of St. Odile is an outsized tympanum composed of Alsatian sandstone set into a beveled-brick border. Eighteen young boy angels play every variety of instrument: strings, brass, and percussion. There is a guitarist angel, an accordionist, a serious young fellow with a violin, and an organist. Another angel blows his bugle as the

sounds of a flute blend with a harpist's strings; a drummer keeps the beat. There's a bagpiper, and boy angels with a horn, a triangle, a bell, and a pan flute. One angel strums his cello, and another his mandolin, while a modern trumpet is played beside an ancient pontic lyra.

Portrayed in repetitive profile as in an Egyptian mural, the poetic array of angels ascend the portal sides like musical notes on a stairway to heaven. Some are in prayer, or hold incense burners or candles; one holds on his head a book symbolizing the monastery's statutes. An angel gracefully offers a church building, evoking St. Odile's first convent in Hohenbourg, while another brings Mother Abbess's crozier. Mosaicist Auguste Labouret's blue glass cabochons punctuate the scene.

In the almond-shaped mandorla, the Virgin brings Odile to Paradise to present her to the Trinity: Jesus, God the Father, and the Holy Spirit depicted as a dove. Odile appears at the age of twelve, when she was baptized; the angels are the same age, creating a charming community of children. The name Odile means "daughter of light"; she is the protector of those who are spiritually and physically blind.

Anne-Marie Roux-Colas consecrated her entire career to religious art; personal piety pervades her work. Her style of spare, sober forms ties her to the figurative tradition of the Art Deco movement. With the angels' orchestra she has paradoxically created a quiet, still elegance that transcends the passage of time.

The church was founded to respond to the spiritual needs of the burgeoning 17th arrondissement, and to recognize the loyalty of the people of the Alsace-Lorraine region during its annexation by Germany following the 1871 Franco-Prussian War. Building began in 1935 on a long, narrow parcel of land with the talented 30-year-old architect Jacques Barge in charge. Despite financing by donors from France and throughout Europe, there were nonetheless hurdles from the start: labor strikes, the onset of World War II, and an intermittent flow of funds. The church was finally completed in 1946; its 72-meter octagonal belfry, the highest in Paris, equals the length of its nave. The church is classified as a historic monument.

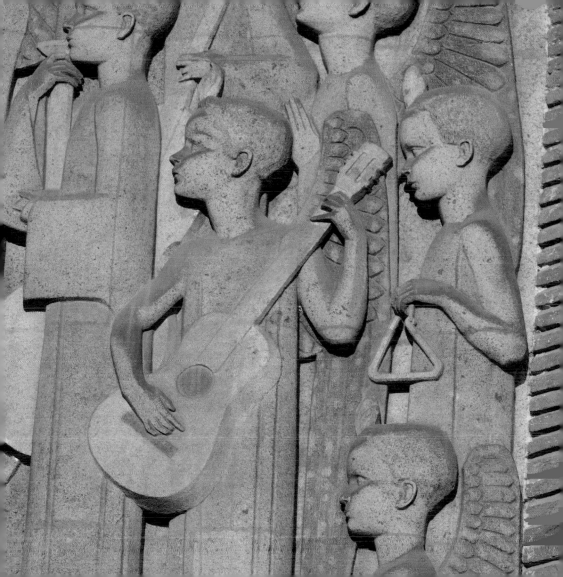

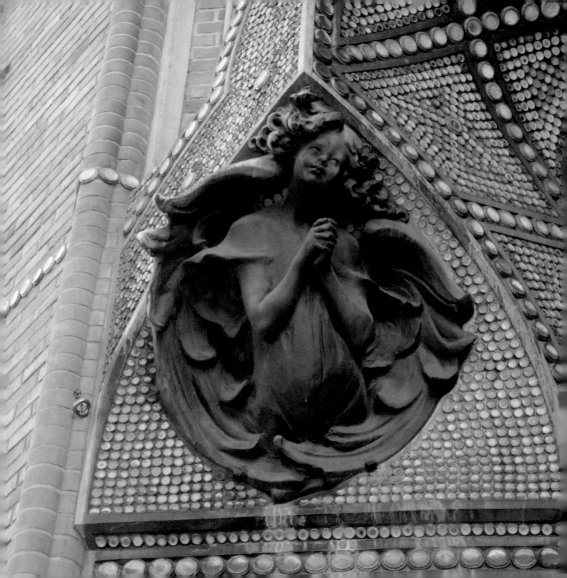

The Art Nouveau Angels
(1904)

✦

Church of St. Jean de Montmartre
19, rue des Abbesses, 18th arr.
Métro: Abbesses

Tucked into beaded, arched alcoves flanking the entrance of the monolithic church of St. Jean de Montmartre, young girl angels billow forward, their great feathery wings unfurling like foamy ocean waves around them. Hands clasped in prayer, curly locks undulating as if swept back by the wind, the angels' sweet faces express enraptured devotion.

Turn-of-the-20th-century architecture was an eclectic mélange of the revival of old styles and the creation of new; St. Jean has a bit of everything: a towering Gothic façade, neo-Byzantine mosaic beadwork, and a touch of Art Nouveau—the new art—inspired by curvy, sinuous lines found in nature, here personified in Pierre Roche's winsome angels, circa 1904.

Roche, a sculptor, painter, and decorator, was at the forefront of the decorative arts movement and a proponent of Art Nouveau. He also created the portal medallion of John the Evangelist holding a cup with an emerging serpent, alluding to the legend in which the saint was given a cup of poisoned wine to drink, from which, upon his blessing, the poison rose in the shape of a serpent.

Construction of the church began in 1894, the culmination of the personal mission of a local priest, Father Sobbeaux, to evangelize the growing population of the southern flank of the *butte* (hill) of Montmartre. Up the hill, Sacré Coeur was still being built, and its medieval neighbor, the former abbey church of St. Pierre de Montmartre, was only large enough to serve the faithful of the summit. Sobbeaux petitioned for funds and hired the innovative architect Anatole de Baudot, who would be the first to use reinforced concrete in a non-industrial edifice. The problem of its unaesthetic surface was resolved by covering it in orange bricks, giving rise to the church's nickname, "St. Jean des Briques"—St. John of the Bricks.

Completed in 1904, the church is part of the parish of Montmartre, and was classified as a historic monument in 1966.

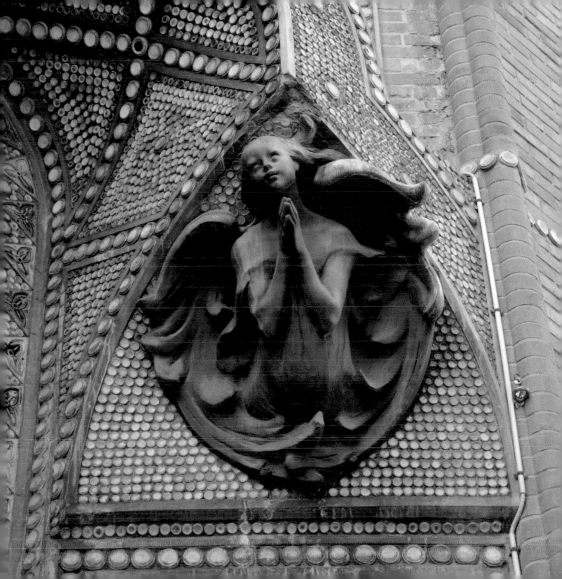

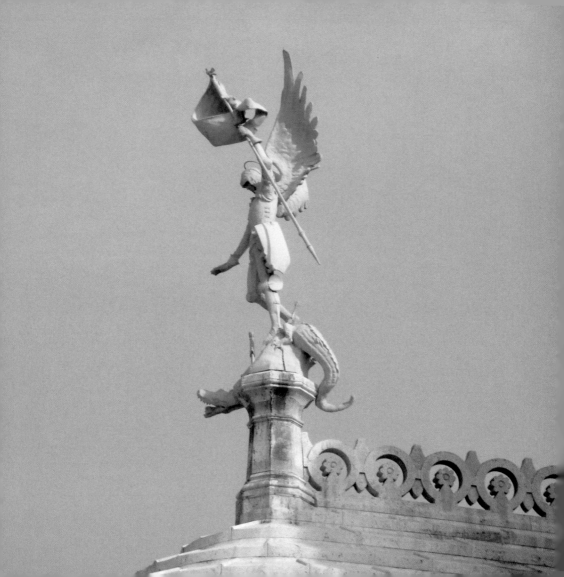

The Angel and the Alligator
(1908)

✦

Basilica of Sacré Coeur
35, rue du Chevalier de la Barre, 18th arr.
Métro: Abbesses

Looking up from the old cobblestoned rue du Chevalier de la Barre, one beholds the dream-like vision of St. Michael the Archangel landing on an enormous alligator atop the apse of the Sacré Coeur, which crowns the highest point of Paris.

The copper statue was a late addition to the church, architect Paul Abadie's eclectic hybrid of a Romanesque façade topped by Byzantine-style dome. A "national vow" sanctioned by the National Assembly in 1873 allowed citizens to contribute to the construction. Work began in 1876, but advanced slowly; the first round of donations would only cover foundation costs that were

higher than anticipated because of hitting bedrock in the loamy soil of the old quarries of the hill of Montmartre. The basilica was partially inaugurated in 1886 and officially consecrated after World War I in 1919.

Many of the additions during the final years were dedicated gifts; one such gift came from the Coutances diocese in Normandy, whose donation committee was presided over by Count Vice-Admiral Jules Marie Armand de Cuverville, a devout Catholic and politician. The statue of

St. Michael was the perfect synthesis of Cuverville's passion for the defense of the Church and for the branch of the military in which he served. The archangel, described in Revelations as the leader of God's army against the forces of evil, is also the patron saint of mariners, based on the legend of his 8th-century apparition at Mont St. Michel. Here, François-Léon Sicard portrays Michael as a spurred medieval knight gliding to a precise and delicate landing on the demon, a giant reptile.

His battle flag doubling as a spear, enormous eagle wings spread wide, St. Michael is gloved, helmeted, and haloed. But the demon, represented in earlier times as a ferocious dragon or a monstrous snake, has metamorphosed into a sleek alligator, its broad snout revealing massive sharp teeth, as its long swerving tail flips up in a curl. He poses no threat to Michael, fitted out from head to toe in full armor complete with epaulettes, knee guards, and a shield hitched to his left hip.

Praised as *l'élégance achevée*—perfect elegance—Sicard's dramatic duo enchanted the public when it was inaugurated in 1908.

Zacharias and Gabriel
(1856)

✦

Church of St. Jean-Baptiste de Belleville
139, rue de Belleville, 19th arr.
Métro: Jourdain

But the angel said unto him, Fear not, Zacharias: for thy prayer is heard;
and thy wife Elisabeth shall bear thee a son, and thou shalt call his name John.
—Luke 1:13

Zacharias, a Levite, and his wife, Elisabeth, a descendant of the House of Aaron, were "well stricken in age" when an angel appears to Zacharias; Biblical scholars estimate his age at approximately 70, and Elisabeth's at about 60. For decades they had suffered the misfortune of Elisabeth's sterility. In the Jewish faith it was considered a malediction, a condition warranting divorce or the taking of a concubine. Yet Zacharias never wavered in his attachment to his wife or in his devotion to his faith.

Here, sculptor Aimé-Napoléon Perrey depicts Zacharias carrying out his duties as temple priest. The offering of incense was one of the most solemn parts of the daily worship. Tradition held that twice a day, the embers of the incense burners were replenished with myrrh to maintain the plume of smoke ascending to heaven with the prayers of the faithful. Lots were drawn each day to determine who should have this honor.

In the Scriptures, there suddenly appears "an angel of the Lord,

standing on the right side of the altar of incense." Perrey takes artistic liberty with the narrative, placing the angel on the left, to fit his wings deftly into the curve of the tympanum. Zacharias is incredulous at the angel's announcement that he will become father of one who will be called John and who will be "great in the sight of the Lord," but the angel assures him: "I am Gabriel, that stand in the presence of God; and am sent to speak unto thee and to shew thee these glad tidings." (Luke 1: 7-19) Gabriel, whose name means "hero of God," is an archangel, one of the seven angels who appear in Revelations.

In 1854 the municipal council of Belleville, then a district outside Paris's walls, selected architect Jean-Baptiste Lassus to design a church of "noble simplicity" in the Gothic style. Lassus, expert in medieval architecture, had been instrumental in the restoration of Sainte-Chapelle and of Notre-Dame Cathedral in Paris. Here, he carried out the council's wishes perfectly. The church, set on a leafy square, is a beauty to behold and has the grandeur of a small cathedral.

Respecting the theological tradition of the Middle Ages—to educate the illiterate in religious dogma through illustration—the tympanum reads from left to right and from bottom to top: "as the eyes are raised, so is the mind exalted." Naturally, the story begins with Gabriel, who has come to promise the miraculous birth of John, on the lower left panel, and ends with the death of John by decapitation, on the upper right. The summit illustrates Christ in majesty.

St. Jean-Baptiste de Belleville is considered a masterpiece of neo-Gothic architecture. The rue Lassus, bordering its west side, is named in honor of its architect.

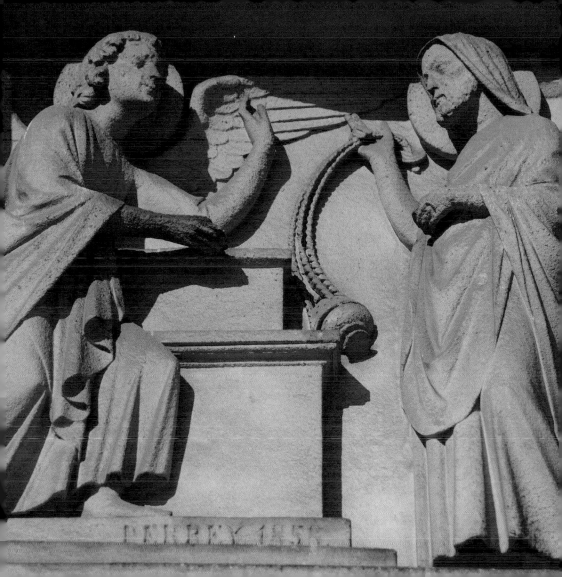

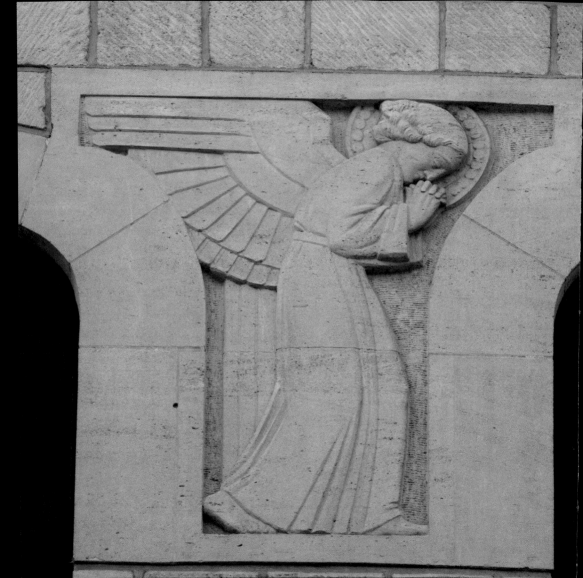

The Angels of the Hostages
(1936)

✦

Church of Notre-Dame-des-Otages
81, rue Haxo, 20th arr.
Métro: Télégraphe

Two angels bow their bodies in silent requiem, one with eyes half closed, hands held in prayer; the other, hands clasped in anguish, stares downward: both seem to express sorrow over the tragic loss of lives in senseless conflict.

In July of 1870 Emperor Napoléon III declared war against Prussia, a catastrophic decision that would cost the lives of 10,000 Parisians, result in the capture of the emperor, and the cession of Alsace-Lorraine. Paris was under siege until January of 1871 when a revolutionary band calling themselves the Communards of Paris, embittered by the French defeat, set fires throughout the city and turned against Adolphe Thiers's provisory government. Forty-nine hostages—ten members of the clergy, thirty-five guardsmen, and five civilians—were taken from the prison on the rue de la Roquette and shot on the rue Haxo by the Communards, during the "bloody week" of May 21 to 28, 1871.

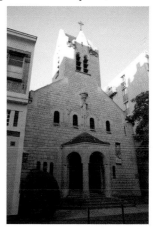

Soon after, two small chapels were planned for the site of the execution. However, it wasn't until 1936 that construction of the present church began; it was completed two years later. Set back from the street and sandwiched between other 20th-century buildings, the church was built by architect Julien Barbier using fine

warm-colored limestone left over from the destruction of the former Palais du Trocadero. The minimalist interior is filled with a subtle glow from stained glass windows set in wall niches.

Roger de Villiers, an acclaimed sculptor of religious subjects, created the angels flanking a statue of the crucified Christ in the Art Deco style, noted for its linear symmetry and inspiration from Aztec and Egyptian art, echoed here in the angels' stylized wings and beaded haloes. De Vil-

liers himself knew war, having served as an officer in World War I. He was awarded the Croix de Guerre and the Legion of Honor.

Behind the church is a monument to those killed during the Commune, including an old door from a prison cell, a piece of the stone wall against which they were shot, and the common grave of their burial. A plaque bears the inscription: "Let us keep the memory of these dramas, not to perpetuate hate, but like Jesus Christ to work for peace among men."

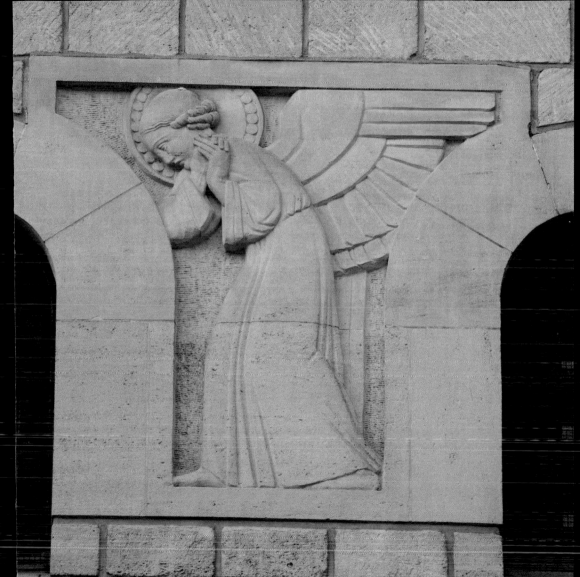

ACKNOWLEDGEMENTS

I am most grateful to the librarians and archivists in Paris who helped in my search for the obscure facts and telling details that illuminated the history of each angel.

Archives de Paris; Archives du Musée National du Moyen Age; Bibliothèque de l'Association pour la Sauvegarde et la Mise en valeur du Paris Historique; Bibliothèque de la Cité de l'architecture et du patrimoine, Palais de Chaillot; Bibliothèque Forney; Bibliothèque Historique de la Ville de Paris; Chambre Professionelle des Artisans Boulangers-Pâtissiers de Paris; Commission du Vieux Paris; Conservation des Oeuvres d'Art Religieuses et Civiles; Service Communication de la Cathédrale Notre-Dame de Paris.

A heartfelt thank you to everyone who supported and encouraged me during this project, especially to my extraordinary publisher, Angela Hederman, the angel of publishing, for her enthusiasm and kindness, and to Jon Kaare Schultz, my erstwhile Viking angel, for his generous help in so many ways.

Thanks also to all who were on "angel alert," letting me know when they sighted one of interest through out Paris, especially Chris Bart, Oriel Caine, Etienne Madranges, and Joseph Poulain. Special thanks to Richard Nahem of Eye Prefer Paris, Karen Fawcett of Bonjour Paris, and Pascal Fonquerie of Paris Marais for posting early versions of my chapters, and to Judy Fayard of *France Today*. For their kind help with technical issues, many thanks to William Nathan and Vincent Gagliostro. *Merci beaucoup* to Jean-Loup Leguay for sharing a scholarly German text regarding the Rodin Museum pediment; *dankeschön* to Bernd Friedrich for translating it. To Patty Lurie, warm thanks for advice and book loans. Very special thanks to Agnes Plaire of COARC who so kindly assisted with research and rejoiced with me when mysteries were revealed. Thanks also to Georges Belleiche for discerning details of the railroad angels. Thanks very much to Veronique Curtinha Baiao, of the Cité de l'Architecture, who made special efforts regarding the Jean-René Debarre panel. Thanks to Jim Dicky, for clarifying military terminology. Gracias to Maria Duff, Mark Gaito, and Susan Kuntz for reading early drafts. Thank you to my agent Deborah Ritchken, who found the perfect publisher. *Un grand merci* to the wonderful team at the Bibliothèque de l'Association pour la Sauvegarde et la Mise en Valeur du Paris Historique. Many thanks to Chantal Ladoux for her kind assistance pertaining to the *amours* of the boulevard Voltaire. Warm thanks to Mary Duncan of Paris Writers Group for her encouragement and support.

BIBLIOGRAPHY

Arminjon, Catherine. *L'Art du métal*. Paris: Editions du Patrimoine, Imprimerie Nationale, 1998.

Babelon, Jean-Pierre, Michel Fleury, and Jacques Silvestre de Sacy. *Richesses d'art du quartier des Halles: maison par maison*. Paris: Arts et métiers graphiques, Flammarion, 1967.

Belleiche, Georges. *Statues de Paris, Les rues de la Rive Gauche*. Paris: Massin, 2006.

Blondel, Jacques-Francois. *Architecture françoise*. Paris: Charles-Antoine Jombert, 1752-1756.

Blunt, Anthony. *Art and Architecture in France, 1500-1700*. London: Penguin Books, 1953.

Boinet, Amédée. *Les Eglises parisiennes*. Tome I: *Moyen âge et Renaissance*; Tome II: *XVIIe siècle*; Tome III: *XVIIe et XVIIIe siècles*. Paris: Editions de Minuit, 1958-1964.

Borrus, Kathy. *Mille monuments*. Paris: Mengès, 2005.

Boutillon, Aline. *Vitrines du passé: L'Art du fixé sous verre à Paris*. Paris: Editions Artena, 2006.

Musée d'Orsay, Catalogue d'exposition. *Auguste Préault: Sculpteur romantique, 1809-1879*. Paris: Gallimard: Réunion des musées nationaux, 1997.

De Moncan, Patrice, and Claude Heurteux. *Le Paris d'Haussmann*. Paris: Les Editions du Mécène, 2002.

Dictionnaire des monuments de Paris. Paris: Editions Hervas, 2003.

Gallet, Michel. *Les architectes parisiens du XVIIIe siècle*. Paris: Editions Mengès, 1995.

Goy-Truffaut, Françoise. *Paris Façade: un siècle de sculptures décoratives*. Paris: Hazan, 1989.

Hillairet, Jacques. *Dictionnaire historique des rues de Paris*. Paris: Editions de Minuit, 1985.

Holy Bible, The: Authorized King James Version. Cleveland: World [Meridian Books], n.d.

Huriet, Geneviève. *Notre Dame de la gare: Histoire d'une paroisse de Paris*. Imprimé par l'église.

Joubert, Pierre. *Les Lys et les lions: initiation à l'art du blazon*. Paris: Les Presses d'Ile de France, 1947.

La Basilique de Notre-Dame des Victoires: Sanctuaire Marial au cœur de Paris. St-Priest: Editions Lescuyer, 2010.

Laget, Pierre-Louis. "Le premier amphithéâtre d'anatomie de la communauté des chirurgiens de

Paris." *Chirurgie* 124 (1999): 681-690. Issy les Moulineaux: Elsevier SAS, Editions scientifiques et medicales.

Lami, Stanislas. *Dictionnaire des sculpteurs de l'école française au XVIIIe siècle*. Paris: Honoré Champion, 1910-1911.

Lami, Stanislas. *Dictionnaire des sculpteurs de l'école française au XIXe siècle*. Paris: Librarie Ancienne Honoré Champion, 1916.

Lami, Stanislas. *Dictionnaire des sculpteurs de l'école française sous le règne de Louis XIV*. Paris: Honoré Champion, 1906.

Larbodière, J-M. *Les plus belles portes de Paris*. Paris: Massin, 2006.

Larbodière, J-M. *Reconnaître les hôtels particuliers parisiens*. Paris: Massin, 2004.

Madranges, Etienne. *Regards sur le Palais dans la Cité*. Paris [Maisons-Alfort]: published by the author, 2002.

Mâle, Emile. *Art et artistes du moyen age*. Paris: Armand Colin, 1947.

Mâle, Emile. *L'Art religieux du XIIe siècle au XVIIIe siècle*. Paris: Armand Colin, 1998.

Mignot, Claude. *Grammaire des immeubles parisiens*. Paris: Parigramme, 2004.

Montagu, Jeremy. *The World of Medieval and Renaissance Musical Instruments*. Woodstock, NY: Overlook Press, 1976.

Parizet, Isabelle. "Méthodologie de la prosopographie à l'époque contemporaine." *In Annuaire de l'Ecole pratique des hautes etudes (EPHE), Section des sciences historiques et philologiques* 142, 2011. Paris: EPHE.

Plessing, Heidemarie. *Giebelskulpturen in Paris von 1660 – 1860: Figurenprogramme der Frontons an öffentlichen Gebäuden*.

Ronzevalle, Edmond. *Paris Xe: histoire, monuments, culture*. Amiens: Martelle Editions, 1993.

Trouilleux, Rodolphe. *Unexplored Paris*. Paris: Parigramme, 2009.

Velmans, Tania. *L'art byzantin*. Rodez: Editions du Rouergue, 2007.

Wundram, Manfred. *Andrea Palladio, Les règles de l'harmonie*. 1508-1580. Köln: Taschen, 2009.

ABOUT THE AUTHOR

© William Nathan

Rosemary Flannery has lived in France since 1989, and enjoys dual French-American nationality. She graduated with honors in French from Columbia University in 1985 with a degree in French language and literature and studied Méthodologie de l'Architecture with Professor Claude Mignot, an authority on Parisian building façades, at the Sorbonne. While at Columbia she co-produced and hosted *French Encounters*, a public-access television program on French culture produced in conjunction with the French Embassy. In 2005 she created and produced *The Art Beat*, a weekly cultural magazine for Paris Live Radio, an internet radio station; several of her programs were picked up by BBC World. Rosemary is an artist and writer and also gives tours of Paris museums and neighborhoods.